TYPOGRAPHICS

the art of typography from digital to dyeline

typographics 1

General Editor: Roger Walton

HDi

HARPER DESIGN international

An Imprint of HarperCollinsPublishers

Typographics 1 is published here with
Typographics 2

Each title first published separately by Hearst Books
International. Now published by
Harper Design International,
an imprint of HarperCollins Publishers
10 East 53rd Street,
New York, NY 10022,
United States of America

ISBN 0688-17875-8

Distributed throughout the world by:
Harper Collins International
10 East 53rd Street
New York, NY 10022,
United States of America
Fax: (212) 207-7654

Each title first published separately
in Germany by NIPPAN
Nippon Shuppan Hanbai
Deutschland GmbH
Krefelder Str. 85
D-40549 Düsseldorf
Telephone: (0211) 5048089
Fax: (0211) 5049326

Edited and Designed by
Duncan Baird Publishers
Castle House
75-76 Wells Street
London W1T 3QH

Designer: Karen Wilks
Editor: Lucy Rix

03 04 05 06 07 / 10 9 8 7 6 5 4 3 2 1

Typeset in Rotis Sans Serif
Color reproduction by Colourscan, Singapore
Printed in China

NOTE: Dimensions for spread formats are single page
measurements; all measurements are for width
followed by height.

FOREWORD

Typographics 1 is the first volume in a series that will bring together recent examples of innovative, experimental, and outstanding work from professional and student typographers. The book is divided into four categories:

Type as Composition, showing designs that use minimal quantities of text;

Type Plus, the alliance of type and imagery;

Type as Text, compositions based on continuous text;

Type Itself, featuring recent font designs.

The aim of the book is not only to generate inspiration and promote debate, but also to focus attention on the current state of typography. The selection of work, made from over 1,000 submissions, was a difficult but rewarding task – the final choice represents the tremendous range and diversity of contemporary design.

In recent years, advanced technology and changing economic conditions have had a profound impact on the teaching and practice of typography. The widespread use of computers has brought about a significant increase in the number of self-initiated publications, many examples of which are shown here. The production costs of a modest publication seem now to

be within the reach of the many rather than the few. This, alongside the imaginative use of digital technology and a wide range of printing processes, has generated a wonderful diversity of material. The work included in this book has been reproduced using litho presses, letter-press printing, silk-screen printing, color xeroxing, monochrome xeroxing, the fax machine, and dyeline processing.

Designers currently enjoy the luxury of access to highly sophisticated technology as well as to older printing and production techniques. It may be that this diversity will be short-lived as the older tools gradually become obsolete. There is, for example, only one design in this book that was originated entirely on a manual typewriter. The authentic typewriter typeface, with all its eccentricities and imperfections, and its connotations of journalistic urgency, is just one form of typographic language that will soon disappear. But the replacement of mechanical techniques

by electronic processes does not necessarily restrict creativity or limit choice. Digital 9
technology opens up new possibilities for the designer: typeface development, the positioning
and repositioning of the elements of a design, the sourcing and manipulation of images,
and the unprecedented speed with which change can be effected, combine in the new
environment in which today's designers work. The dramatic pace of technological change
also ensures that new techniques are discovered daily – by the time this book is printed, the
software with which it was created will already have been modified.

Future editions of **Typographics** will continue to focus on changing trends in design and will draw on an
even broader range of sources. As technological developments further influence typography,
and as older traditions are reassessed and reappropriated, the most inspiring results will be
celebrated here.

R.W.

type as composition
type as composition

type as composition

designer
Dirk van Dooren

design company
Tomato

country of origin
UK

work description
Typo-psalm, a page from
Jetset magazine

dimensions
268 x 345 mm
10½ x 13⅝ in

12

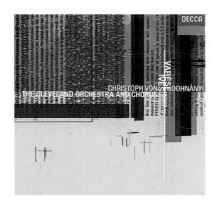
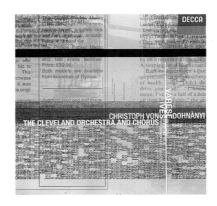

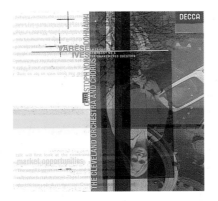
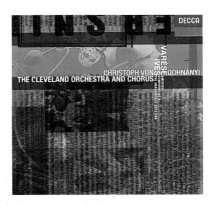

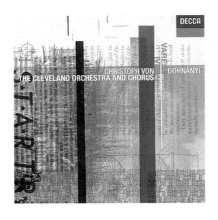
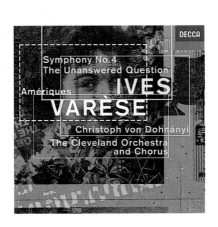

designer
Nick Bell

art director
David Smart

design company
Nick Bell

country of origin
UK

work description
CD cover visuals for
Decca records, using
multi-printed litho press
set-up sheets that allude
to the layered nature of
Ives' music

dimensions
120 x 120 mm
4³⁄₄ x 4³⁄₄ in

designer
Melle Hammer

design company
Plus X

country of origin
The Netherlands

work description
Case binding of the book
Een Vaste Vriend, for
Contact Publishers

dimensions
shown actual size
128 x 190 mm
5 x 7½ in

14

een vaste vriend

roman
Mirjam Windrich

designer
Irma Boom

design company
Irma Boom

country of origin
The Netherlands

work description
Card-coverings from *The Spine*, publications bound together to form a single volume, published by De Appel Foundation

dimensions
300 x 210 mm
11⅞ x 8¼ in

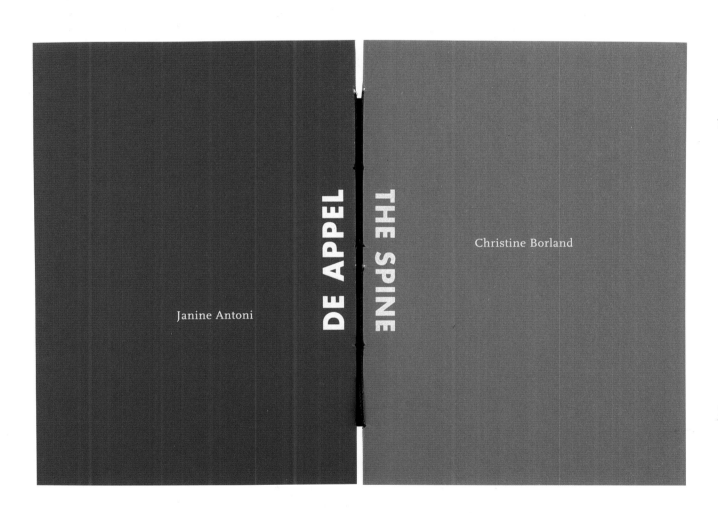

designers
Mario A. Mirelez
Jim Ross

16 **art director**
Mario A. Mirelez

design company
Mirelez/Ross Inc.

country of origin
USA

work description
Exhibition catalog cover,
for the Herron Gallery

dimensions
280 x 227 mm
11 x 8⁷⁄₈ in

designer
Robbie Mahoney

college
Central Saint Martin's
College of Art and Design,
London

country of origin
UK

work description
Spreads from an
experimental magazine

dimensions
445 x 297 mm
17½ x 11¾ in

John Zorn

My background was mostly classical, studying composition, and through that I went towards improvisation - through having performers mess up my pieces to the extent that I felt I should do them myself, and have them realised in such a way that they couldn't be messed up.

Were you playing saxophone in those pieces?

other places

Other windows

designer
André Baldinger

college
Atelier National de
Création Typographique,
Paris

18

country of origin
France

work description
Poster for the Atelier
National de Création
Typographique

dimensions
274 x 410 mm
10³⁄₄ x 16¹⁄₈ in

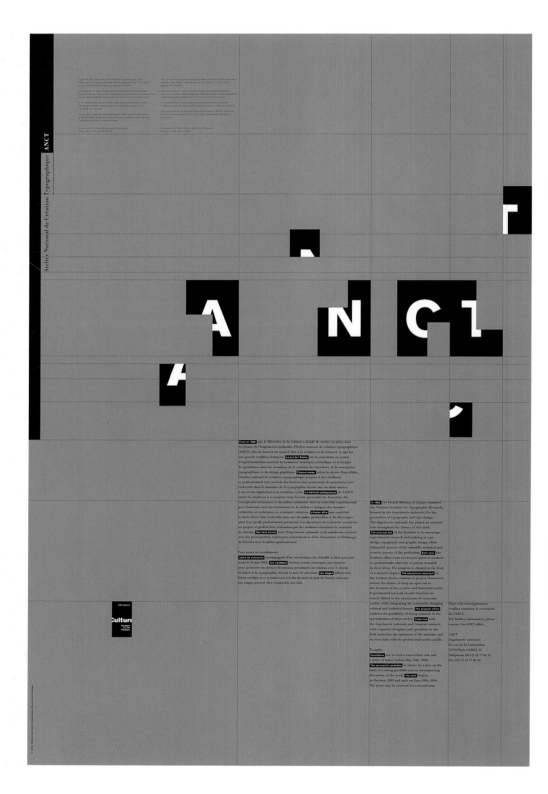

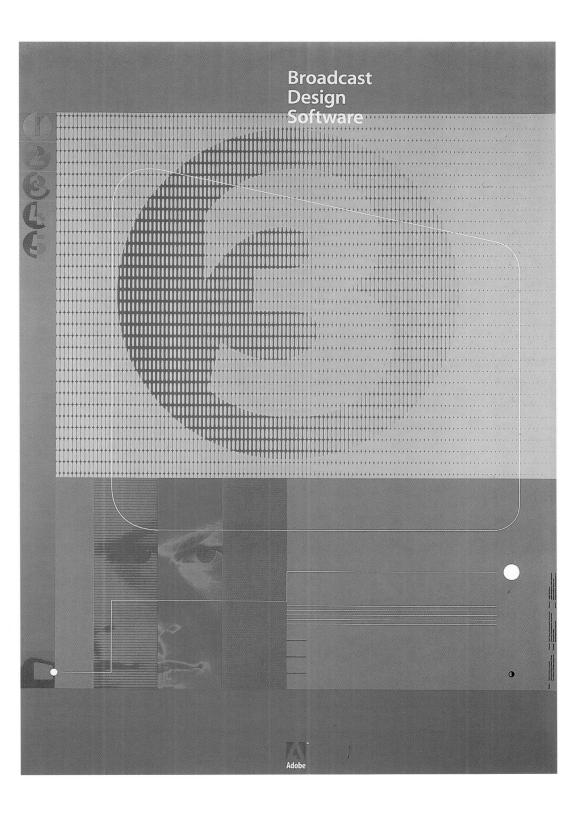

designer
Michael Renner

photographer
Michael Renner

design company
Michael Renner Design

country of origin
Switzerland

work description
*Broadcast Design
Software*, a poster for
Adobe Systems Inc.

dimensions
905 x 1275 mm
35⅝ x 50 in

19

designer
Irma Boom

design company
Irma Boom

country of origin
The Netherlands

work description
Case binding from an
exhibition catalog, *Round
Transparency, Marian
Bijlenga 1993*

dimensions
198 x 198 mm
7¾ x 7¾ in

designer
Irma Boom

design company
Irma Boom

photographer
Ido Menco

country of origin
The Netherlands

work description
Case binding from an
exhibition catalog, *Tomas
Rajlich*

dimensions
161 x 208 mm
6⅜ x 8¼ in

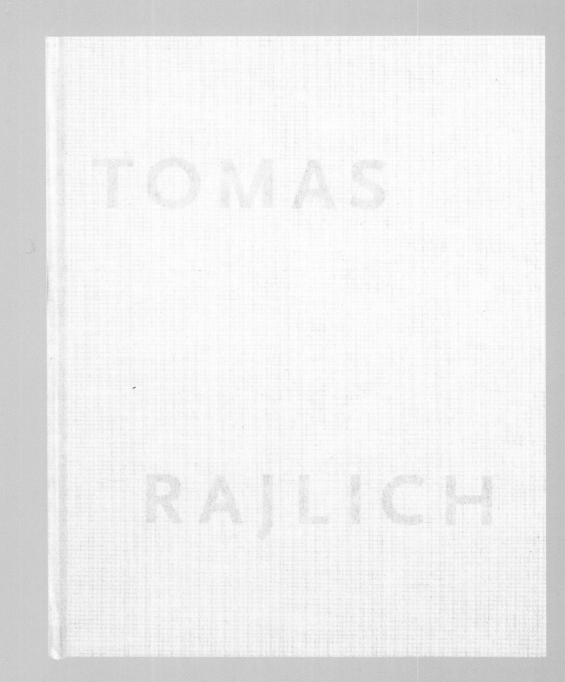

designer
Willi Kunz

design company
Willi Kunz Associates

country of origin
USA

work description
Lecture series posters for
Columbia University,
Graduate School of
Architecture, Planning,
and Preservation, New
York

dimensions
304 x 610 mm
12 x 24 in

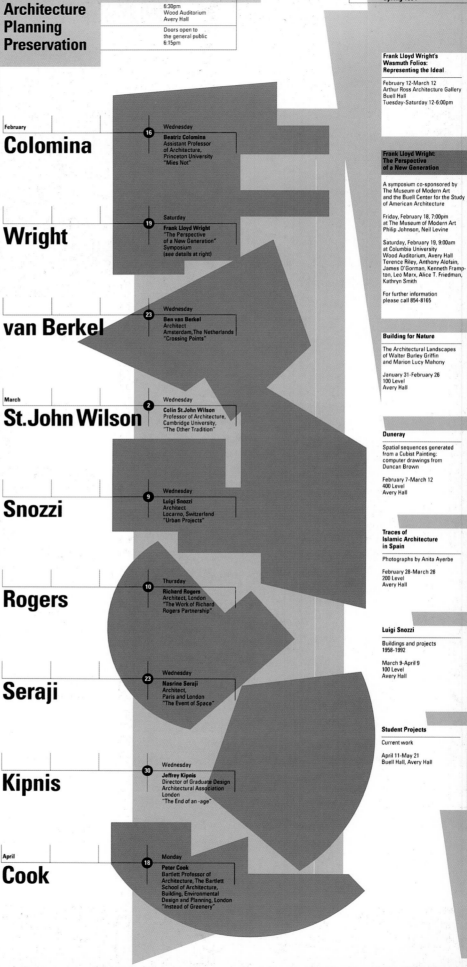

Columbia
Architecture
Planning
Preservation

Lectures

6:30pm
Wood Auditorium
Avery Hall

Doors open to
the general public
6:15pm

Exhibitions and Symposia
Spring 1994

February

Colomina

Wednesday
16 **Beatriz Colomina**
Assistant Professor
of Architecture,
Princeton University
"Mies Not"

Wright

Saturday
19 **Frank Lloyd Wright**
"The Perspective
of a New Generation"
Symposium
(see details at right)

van Berkel

Wednesday
23 **Ben van Berkel**
Architect
Amsterdam, The Netherlands
"Crossing Points"

March

St. John Wilson

Wednesday
2 **Colin St. John Wilson**
Professor of Architecture,
Cambridge University,
"The Other Tradition"

Snozzi

Wednesday
9 **Luigi Snozzi**
Architect
Locarno, Switzerland
"Urban Projects"

Rogers

Thursday
10 **Richard Rogers**
Architect, London
"The Work of Richard
Rogers Partnership"

Seraji

Wednesday
23 **Nasrine Seraji**
Architect,
Paris and London
"The Event of Space"

Kipnis

Wednesday
30 **Jeffrey Kipnis**
Director of Graduate Design
Architectural Association
London
"The End of an -age"

April

Cook

Monday
18 **Peter Cook**
Bartlett Professor of
Architecture, The Bartlett
School of Architecture,
Building, Environmental
Design and Planning, London
"Instead of Greenery"

Frank Lloyd Wright's
Wasmuth Folios:
Representing the Ideal

February 12-March 12
Arthur Ross Architecture Gallery
Buell Hall
Tuesday-Saturday 12-6:00pm

Frank Lloyd Wright:
The Perspective
of a New Generation

A symposium co-sponsored by
The Museum of Modern Art
and the Buell Center for the Study
of American Architecture

Friday, February 18, 7:00pm
at The Museum of Modern Art
Philip Johnson, Neil Levine

Saturday, February 19, 9:00am
at Columbia University
Wood Auditorium, Avery Hall
Terence Riley, Anthony Alofsin,
James O'Gorman, Kenneth Framp-
ton, Leo Marx, Alice T. Friedman,
Kathryn Smith

For further information
please call 854-8165

Building for Nature

The Architectural Landscapes
of Walter Burley Griffin
and Marion Lucy Mahony

January 31-February 26
100 Level
Avery Hall

Duneray

Spatial sequences generated
from a Cubist Painting:
computer drawings from
Duncan Brown

February 7-March 12
400 Level
Avery Hall

Traces of
Islamic Architecture
in Spain

Photographs by Anita Ayerbe

February 28-March 26
200 Level
Avery Hall

Luigi Snozzi

Buildings and projects
1958-1992

March 9-April 9
100 Level
Avery Hall

Student Projects

Current work

April 11-May 21
Buell Hall, Avery Hall

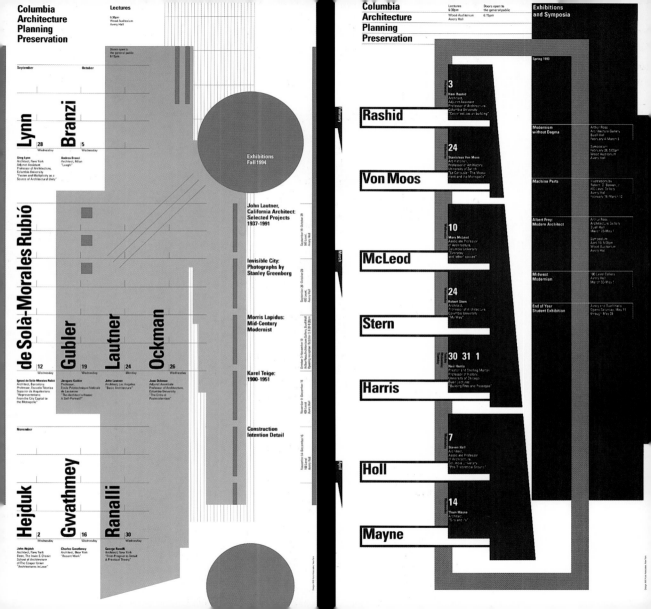

Columbia Architecture Planning Preservation

Lectures 6:30pm
Wood Auditorium
Avery Hall

Doors open to the general public 8:15pm

September October

Lynn 28 Wednesday **Branzi** 5 Wednesday

Greg Lynn
Architect, New York
Adjunct Assistant
Professor of Architecture,
Columbia University
"Fusion and Multiplicity as a
Source of Architectural Unity"

Andrea Branzi
Architect, Milan
"Luogh"

Exhibitions
Fall 1994

de Solà-Morales Rubió 12 Wednesday **Gubler** 19 Wednesday **Lautner** 24 Monday **Ockman** 26 Wednesday

Ignasi de Solà-Morales Rubió
Architect, Barcelona
Professor, Escuela Tecnica
Superior de Arquitectura
"Representations:
From the City Capital to
the Metropolis"

Jacques Gubler
Professor,
Ecole Polytechnique Fédérale
de Lausanne
"The Architect's Praise:
A Self-Portrait"

John Lautner
Los Angeles
"Basic Architecture"

Joan Ockman
Adjunct Associate
Professor of Architecture,
Columbia University
"The Ends of
Postmodernism"

John Lautner,
California Architect:
Selected Projects
1937-1991

Invisible City:
Photographs by
Stanley Greenberg

Morris Lapidus:
Mid-Century
Modernist

Karel Teige:
1900-1951

Construction
Intention Detail

November

Hejduk 2 Wednesday **Gwathmey** 16 Wednesday **Ranalli** 30 Wednesday

John Hejduk
Architect, New York
Dean, The Irwin S. Chanin
School of Architecture
of The Cooper Union
"Architecture in Love"

Charles Gwathmey
Architect, New York
"Recent Work"

George Ranalli
Architect, New York
"From Program to Detail
A Practical Theory"

Columbia Architecture Planning Preservation

Lectures 6:30pm
Wood Auditorium
Avery Hall

Doors open to the general public 6:15pm

Exhibitions and Symposia

Spring 1993

Rashid 3 Wednesday

Hani Rashid
Architect,
Adjunct Assistant
Professor of Architecture,
Columbia University
"Ceci n'est pas un building"

Von Moos 24 Wednesday

Stanislaus Von Moos
Art historian,
Professor of Art History,
University of Zurich
"Le Corbusier: The Monu-
ment and the Metropolis"

McLeod 10 Wednesday

Mary McLeod
Associate Professor
of Architecture,
Columbia University
"Everyday
and 'other' spaces"

Stern 24 Wednesday

Robert Stern
Architect,
Professor of Architecture,
Columbia University
"My Way"

Harris 30 31 1 Tuesday Wednesday Thursday

Neil Harris
Preston and Sterling Morton
Professor of History,
University of Chicago
Buell Lectures
"Building Rites and Passages"

Holl 7 Wednesday

Steven Holl
Architect,
Associate Professor
of Architecture,
Columbia University
"The Theoretical Ground"

Mayne 14 Wednesday

Thom Mayne
Architect
"Is's and 'is"

Modernism
without Dogma

Arthur Ross
Architecture Gallery
Buell Hall
February 4-March 5

Symposium:
February 26, 5:00pm
Wood Auditorium
Avery Hall

Machine Parts

Illustrations by
Robert D. Bowen, Jr.
400 Level, Gallery
Avery Hall
February 16-March 12

Albert Frey:
Modern Architect

Arthur Ross
Architecture Gallery
Buell Hall
March 23-May 1

Symposium:
April 19, 6:30pm
Wood Auditorium
Avery Hall

Midwest
Modernism

400 Level Gallery
Avery Hall
March 23-May 1

End of Year
Student Exhibition

Avery and Buell Halls
Opens Saturday, May 15
through May 29

designer
Sloy

art director
Rudy VanderLans

design company
Emigre Graphics

country of origin
USA

work description
Advertising poster for
Emigre Graphics,
handlettered by Sloy

dimensions
830 x 570 mm
32⅝ x 22½ in

designer
Luca Dotti

college
Atelier Nationale de
Création Typographique,
Paris

26

country of origin
France

work description
Poster for Atelier
Nationale de Création
Typographique

dimensions
1700 x 596 mm
66⅞ x 23½ in

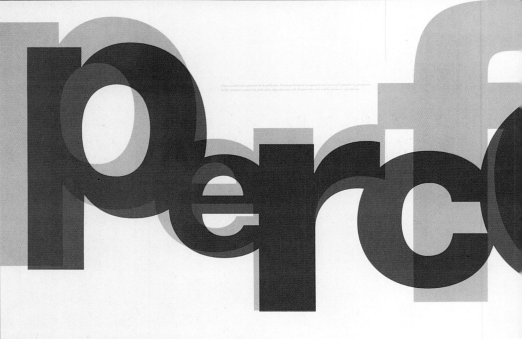

27

eption

© Atelier National de Création Typographique / Design: Luca Dotti

In 1985, the French Ministry of Culture launched the National Institute for Typographic Research, housed by the Imprimerie nationale, for the promotion of typography and type design.

The Imprimerie Nationale has played an essential role throughout the history in this field.

The principal aim of the Institute is to encourage experimental research and training in type design,

typography and graphic design, while taking full account of the scientific, technical and creative aspects of the profession.

Each year, the Institute offers a one or two year grant to students or professionals who wish to pursue research in these areas.

The program is situated at the level of a master's degree.

The educational approach of the Institute invites students to project themselves toward the future,

to keep an open ear to the demands of the creative and industrial world. Experimental research should therefore be closely linked to the constraints of economic reality,

while integrating the constantly changing cultural and technical factors.

The program offers students the possibility of doing research in the specialization of their choice.

Close ties with the Imprimerie nationale and frequent contacts with respected designers and specialists in the field underline

the openness of the Institute and its close links with the professional world outside.

To apply:

Candidates are to send a curriculum vitae and a letter of intent before May 31st, 1994.

The successful candidate is chosen by a jury on the basis of a strong portfolio and an accompanying discussion of the work.

The term begins in October, 1994 and ends on June 30th, 1995.

The grant may be renewed for a second year.

designer
The Designers Republic

country of origin
UK

work description
Dos Dedos Mis Amigos LP
by Pop Will Eat Itself
(Infectious Records, UK);
center of a gatefold
sleeve

dimensions
430 x 310 mm
16⅞ x 12¼ in

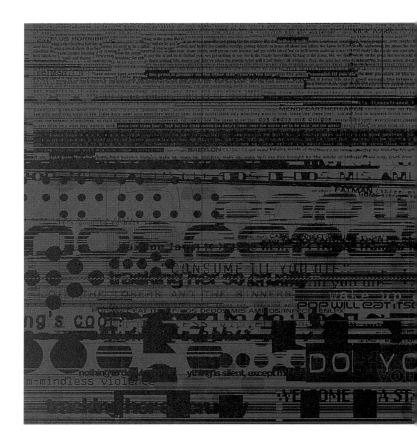

designer
The Designers Republic

country of origin
UK

work description
Aaah EP by Sun Electric,
(R & S records, Belgium);
center of a gatefold
sleeve

dimensions
430 x 310 mm
16⅞ x 12¼ in

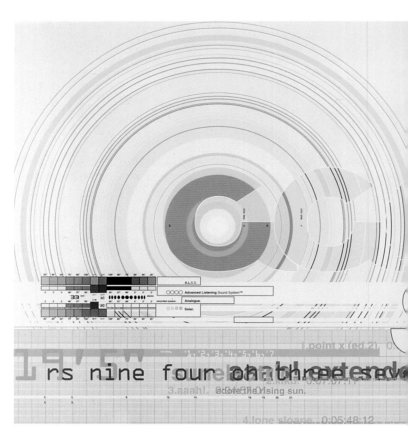

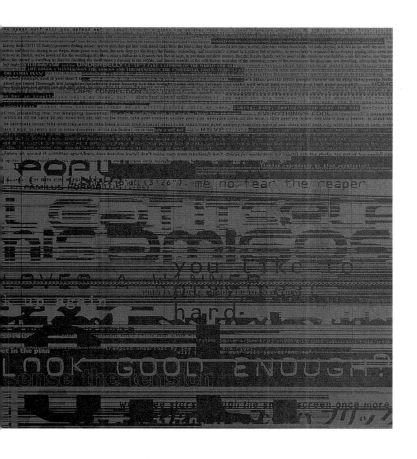

29

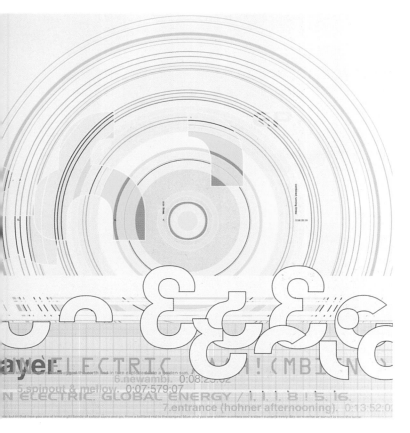

designer
Caroline Pauchant

college
Ecole Nationale
Supérieure des Arts
Décoratifs, Paris

tutor
Philippe Apeloig

country of origin
France

work description
Qu'est ce que tu dis?, a
project based on a poem
by Raymond Queneau

dimensions
180 x 261 mm
7⅛ x 10¼ in

30

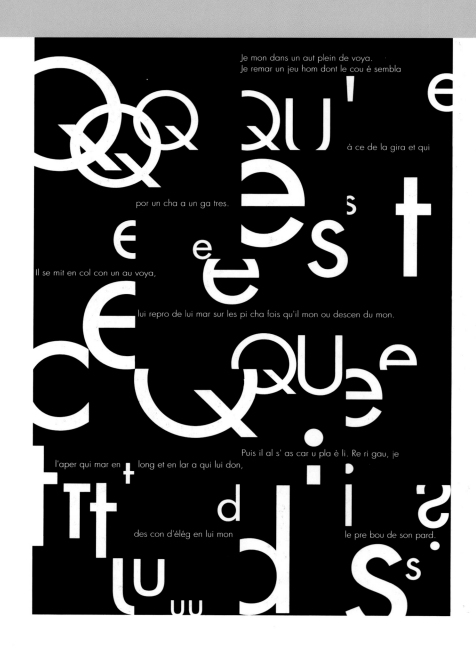

Déjeuner le matin
Il a mis le café
il a mis le lait
dans la tasse de café
il a mis le sucre
dans le café au lait
avec la petite cuillère
il l'a tourné
il a bu le café au lait

et il a reposé la tasse
sans me parler
il a allumé
une cigarette
il a fait des rondes
avec la fumée
il a mis les cendres
dans le cendrier
sans me parler

sans me regarder
il s'est levé
il a mis son chapeau
sur la tête
il a mis son
manteau de pluie
parce qu'il pleuvait
et il est parti
sous la pluie

silence

sans une parole
sans me regarder
et moi j'ai pris ma
tête dans ma main
et j'ai pleuré.
Jacques Prévert

«qui parle avec moi?»

**Nous sommes
des muets
dans le monde
des muets.**

**Donc c'est à nous
de faire l'effort
d'apprendre leur
langage des signes
pour communiquer
avec eux.**

muets

designer
Anje Booken

college
Ecole Nationale
Supérieure des Arts
Décoratifs, Paris

tutor
Philippe Apeloig

country of origin
France

work description
Muets/Silence, a project
based on a poem by
Jacques Prévert

dimensions
170 x 220 mm
6¾ x 8⅝ in

designer
Christophe Ambry

college
Ecole Nationale
Supérieure des Arts
Décoratifs, Paris

tutor
Philippe Apeloig

country of origin
France

work description
Project on Dyslexia

dimensions
200 x 303 mm
7⅞ x 11⅞ in

32

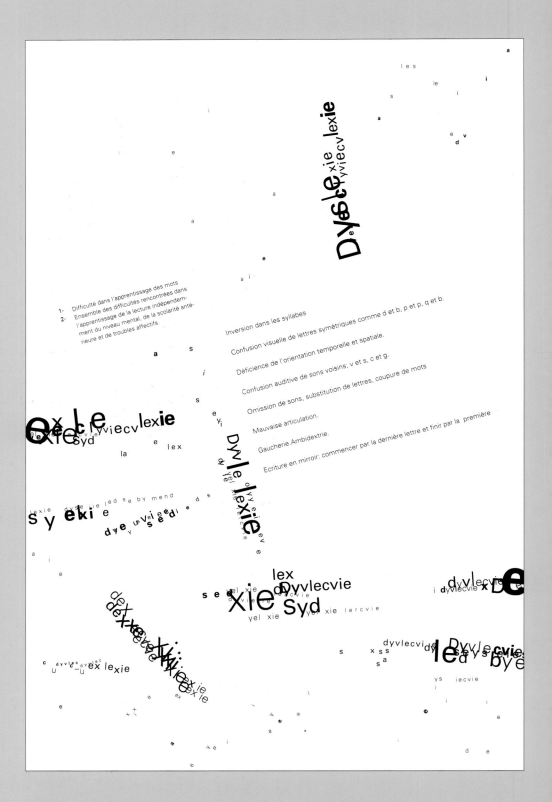

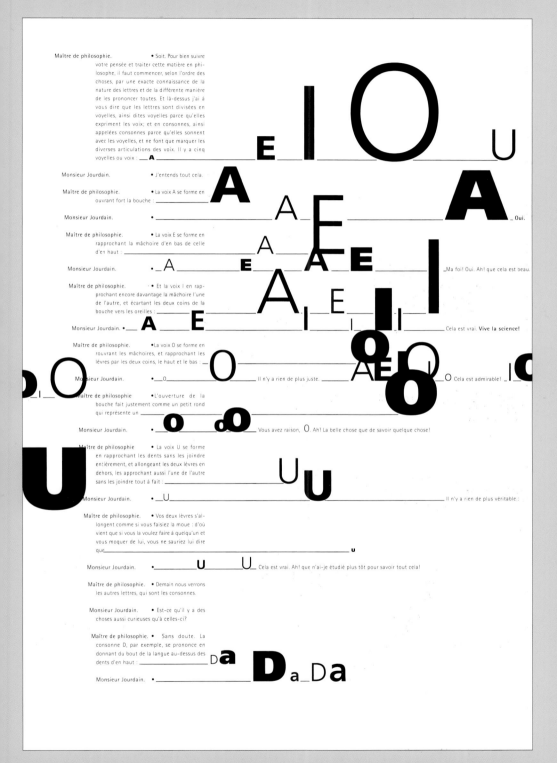

designer
Jérôme Mouscadet

college
Ecole Nationale
Supérieure des Arts
Décoratifs, Paris

tutor
Philippe Apeloig

country of origin
France

work description
AEIOU, a project based
on *Le Bourgeois
Gentilhomme*, a play
by Molière

dimensions
244 x 360 mm
9⅝ x 14⅛ in

33

designer
Dirk van Dooren

design company
Tomato

country of origin
UK

work description
Detail from a poster
for the Institute of
Contemporary Art,
London

dimensions
550 x 510 mm
21 ⅝ x 20 in

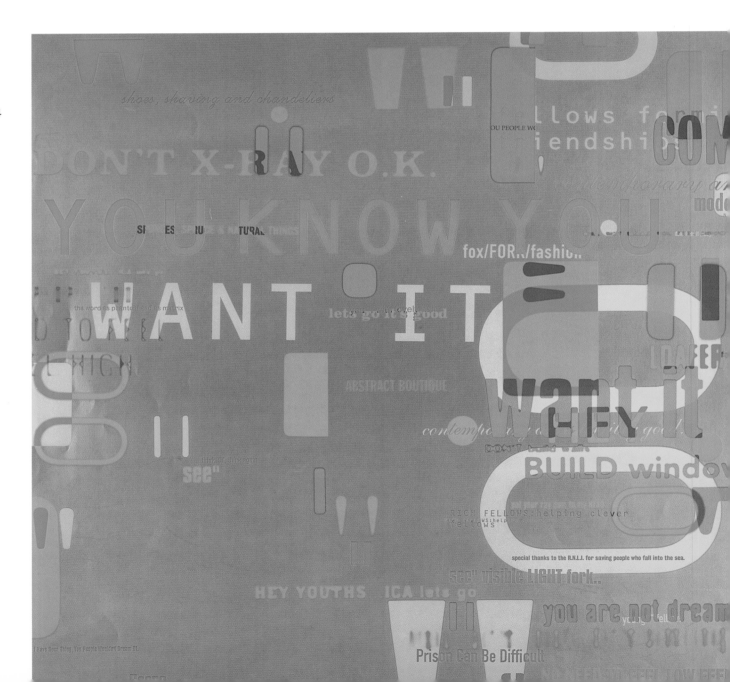

designers
Lies Ros
Rob Schröder

design company
Wild Plakken

country of origin
The Netherlands

work description
The last poster of the
Dutch Anti-Apartheid
Movement, announcing
an event to celebrate the
end of apartheid in South
Africa: BLANK (white)
and BLACK (black)
cooperating

dimensions
594 x 840 mm
23⅜ x 33 in

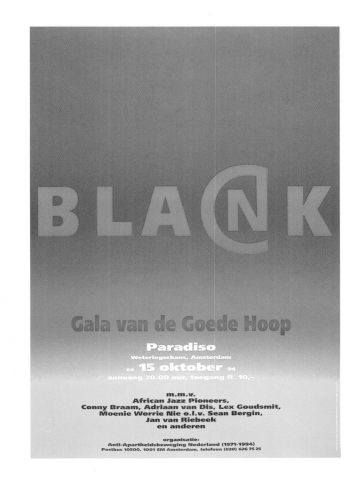

designer
Melle Hammer

design company
Plus X

country of origin
The Netherlands

work description
Het Ontbrekend Teken [*The Missing Sign*], a poster

dimensions
605 x 280 mm
23¾ x 11 in

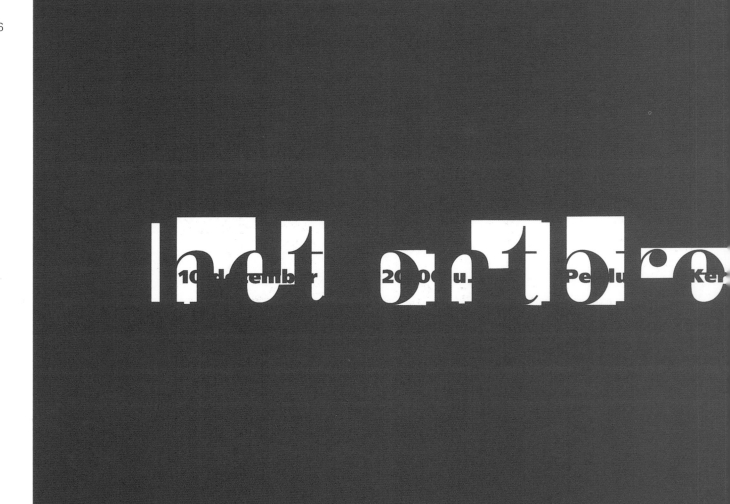

zaterdag 10 december
aanvang: 20.00 u.
Stichting Perdu,
Kerkstraat 391
Toegang ƒ 7.50
Tel. 6234874
'Het ontbrekend
door de vakklas
typografie van
Gerrit Rietveld
samen met Stichting Perdu en
veertien auteurs

designer
Karen Wilks

design company
Karen Wilks Associates

country of origin
UK

work description
One from a set of four
self-promotional
postcards for 1994

dimensions
105 x 148 mm
4⅛ x 5⅞ in

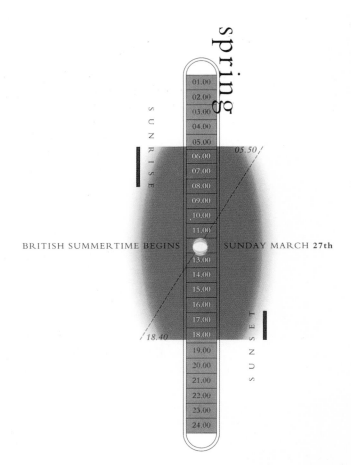

BRITISH SUMMERTIME BEGINS　　SUNDAY MARCH **27th**

karen wilks

designer
Karen Wilks

design company
Karen Wilks Associates

country of origin
UK

work description
One from a set of four
self-promotional
postcards for 1995

dimensions
148 x 105 mm
5⅞ x 4⅛ in

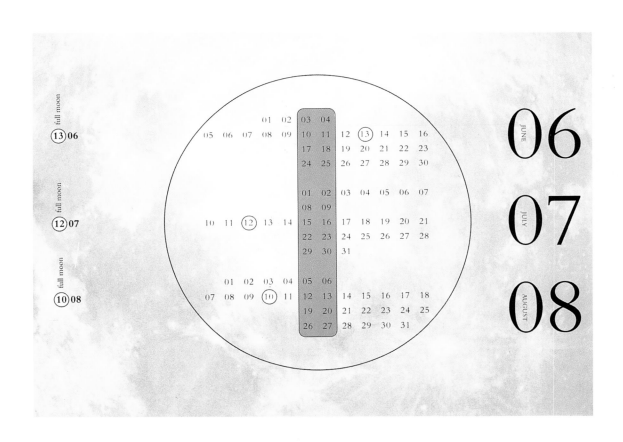

designer
Huw Morgan

country of origin
UK

work description
Idiot Boy, a project for
the Royal College of Art,
London, that explores
attitudes toward the
mentally ill

dimensions
1524 x 1016 mm
60 x 40 in

40

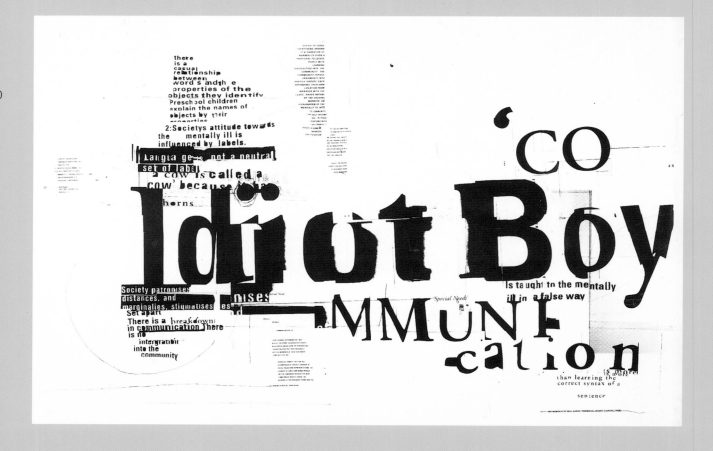

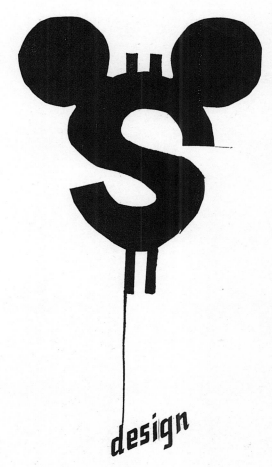

design

INTERNSHIP

$400—500 WEEKLY

The Disney Store, Inc.

SUBMIT RESUME AND COVER LETTER TO STUDENT AFFAIRS

SEE WILHEMINE SCHAEFFER FOR DETAILS

designers
Michael Worthington
Christa Skinner

college
California Institute of
the Arts

country of origin
USA

work description
*Internship: The Disney
Store Inc.*, a poster

dimensions
280 x 431 mm
11 x 17 in

41

designers
Betina Muller
Birgit Tummers
Claudia Trauer
Nauka Kirschner
Petra Reisdorf

design company
Atelier

country of origin
Germany

work description
Berliner Sommernacht der Lyrik, third in a series of posters for the annual summernight of lyric poetry, read in the garden of the Berlin Literaturwerkstatt [literature workshop]

dimensions
840 x 594 mm
33⅛ x 23⅜ in

3.
berliner
sommernacht
der lyrik

es lesen
Jürgen Becker, Köln
Inger Christensen, Kopenhagen/Dk
Elfriede Czurda, A, Berlin
Oswald Egger, Wien/A
Michael Hamburger, Middleton/GB
Rainer Kirsch, Berlin
Uwe Kolbe, Berlin
Brigitte Oleschinski, Berlin
Detlev Meyer, Berlin
Dirk v. Petersdorff, Kiel
Ilma Rakusa, Zürich/CH
Thomas Rosenlöcher, Dresden
Wolfgang Schlenker, Berlin
Kiev Stingl, Berlin
Yoko Tawada, Japan, Hamburg
Peter Waterhouse, Wien/A

in memoriam: Franz Kafka

es spielt
Krautgarden
Berlin, Leipzig
Jürgen Kupke, clarinet
Theo Nabicht, saxophone
Bert Wrede, guitar
Horst Nonnenmacher, bass
Michael Clifton, drums

es moderiert
Peter Geist, Leipzig

für Speisen, Getränke, Büchertisch sowie Taxistand ist gesorgt

in Haus und Garten der
literaturWERKstatt Berlin
Majakowskiring 46/48
13 156 Berlin

25. Juni 94
Einlaß ab 20 Uhr, Beginn 21 Uhr

Eine Gemeinschaftsveranstaltung der literaturWERKstatt berlin und der Stiftung Preußische Seehandlung, mit freundlicher Unterstützung des Kulturamts Pankow

designer
Jim Ross

design company
Mirelez/Ross Inc.

country of origin
USA

work description
Clayfest No. 8, an
exhibition poster

dimensions
660 x 874 mm
25⅜ x 34⅜ in

HERRON GALLERY
Indianapolis Center for Contemporary Art
CLAYFEST No. 8
A Juried Biennial of
INDIANA CERAMIC ARTISTS
and
AMACO SELECTS: TEN YEARS OF CERAMIC WORKSHOPS

DECEMBER *5, 1992* - JANUARY *8, 1993*

HERRON SCHOOL OF ART
1701 N. PENNSYLVANIA ST.
INDIANAPOLIS, IN. 46202
317 920-2420

MONDAY - THURSDAY
10:00 AM TO 7:00 PM
FRIDAY 10:00 AM TO 5:00 PM

These exhibitions are funded in part by The Mary Howes
Woodsmall Foundation, American Art Clay Co., Inc., the Friends
of Herron, the Indiana Arts Commission and the National
Endowment for the Arts.

designers
Karl Hyde
John Warwicker

design company
Tomato

country of origin
UK

work description
Spreads and details from
the book *Skyscraper*, for
Booth–Clibborn publishers

dimensions
205 x 297 mm
8⅛ x 11¾ in

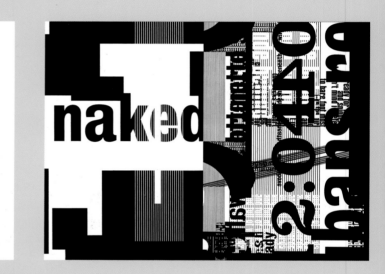

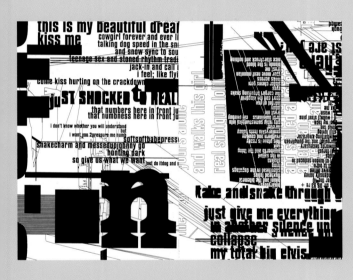

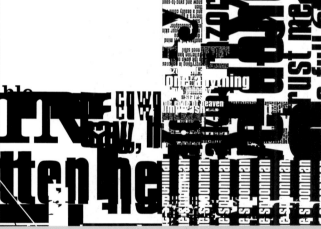

designers
Fernando Gutiérrez
Pablo Martín

photographer
Marie Espeus

art director
Fernando Gutiérrez

design company
Martín & Gutiérrez

country of origin
Spain

work description
Front cover, cover verso,
title, and opening page of
text from an exhibition
catalog

dimensions
165 x 295 mm
6½ x 11⅝ in

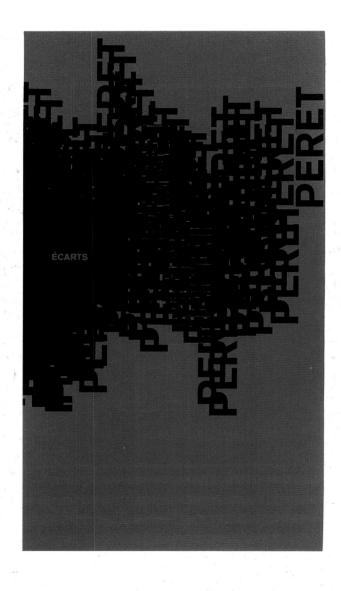

ÉCARTS

PERET

SEPTEMBRE NOVEMBRE 1994

LE MONDE DE L'ART

PARIS

Dans

la hiérarchie des acceptions du mot écart que l'on trouve dans Le Petit Robert celle avec qui je m'identifie le plus est celle définie en numéro 6. On y lit: "Loc. adv. À L'ÉCART, dans un endroit écarté, à une certaine distance (de la foule, d'un groupe). V. Loin... etc." Et pour préciser encore plus, c'est avec le sens à une certaine distance que je m'identifie. Pointilleux je le suis, je tiens à signaler que ce n'est pas à distance de la foule ou d'un groupe que je veux me placer, au contraire, c'est plutôt à une certaine distance de moi-même que je cherche à me tenir. Jusqu'à présent, j'ai travaillé dans le graphisme et l'illustration. J'ai pu jouer avec toute sorte de moyens d'expression. J'ai touché à tout, ou presque, dans le domaine de la communication. Mais on n'exerce pas impunément un métier pendant vingt cinq années sans s'en lasser. C'est donc un écart par rapport à une route professionnelle, qui, même variée, est trop balisée et n'arrive plus à combler les caprices de ma curiosité. Le seul moyen, pour moi, d'y échapper, c'était de suivre une impulsion, de travailler sur une intuition.

Malheureusement cela n'a pas été facile. Car ce n'est qu'avec une perspective différente que l'on peut essayer de se comprendre, de saisir l'ensemble. Se voir du dehors pour essayer de décortiquer ce qu'on est et ce qu'on fait, bien qu'être et faire soient inextricablement liés

Tout d'abord pas l'effet de miroir, car rien de mieux qu'un miroir pour avoir une approche de soi-même. Un de mes amis soutient que l'on est obligé de cultiver les symboles dans lesquels on se reconnaît et qui nous constituent, que c'est dans la qualité des miroirs, dans lesquels on cherche notre reflet, que l'on peut récupérer notre fragile identité et mesurer notre taille. Je ne saurais être plus en accord. Les miroirs dans lesquels je suis allé me chercher ont été variés mais reliés par le fil invisible des affinités. Je leur en suis, aujourd'hui, très reconnaissant à ces miroirs, car ils ne m'ont pas seulement renvoyé mon image, ils me l'ont rendue enrichie de tous leurs trésors et en plus ils m'ont appris à regarder. À regarder, à voir et à apprécier la richesse cachée dans le plus humble des objets. ▶▶

designer
Alan Kitching

illustrator
Raffaella Fletcher

design company
The Typography Workshop

art director
Alan Kitching

country of origin
UK

work description
Posters and the slip-case
(overlaid, right) from *A
Brief History of Type* (self-
published)

dimensions
slip-case
210 x 210 mm
8¼ x 8¼ in

classic ['klaesik],
1. *adj*., -al, *adj*.
KLASSISCH.

Justus Erich Walbaum of Weimar 1800

INFERNO AmerikAtla

A Brief History of Type

Che la verace via abbandonai.
Tant' era pien di sonno in su quel punto,
I' non so ben ridir com' i' v'intrai,
Dico dell' altre cose ch' io v'ho scorte.
Ma per trattar del ben ch' i' vi trovai,
Tanto è amara, che poco è più morte;
Che nel pensier rinnova la paura!
Questa selva selvaggia ed aspra e forte,
Ahi quanto, a dir qual era, è cosa dura,
Che la diritta via era smarrita.
Mi ritrovai per una selva oscura,
...mezzo del cammin di nostra vita

Blado & Poliphilus (1499)

DANTE L'ntiCable. 1927

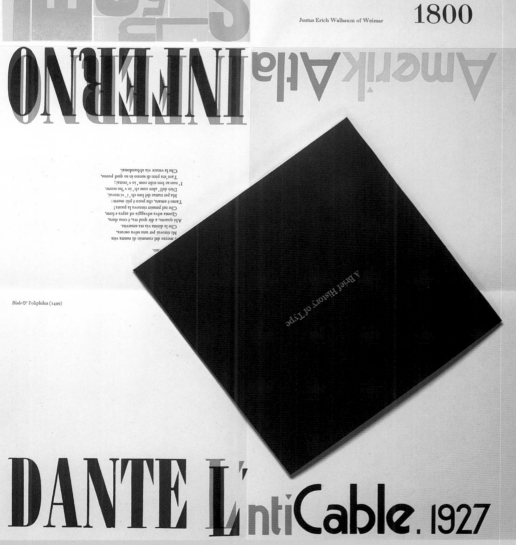
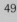

49

designer
Anukam Edward Opara

college
London College of
Printing and Distributive
Trades

country of origin
UK

work description
HET, a page from a
calendar of typographers
and designers: Julius
[June] represents the
Hungarian designer,
Moholy-Nagy, with the
typeface Akzindenz
Grotesk Regular

dimensions
1680 x 2376 mm
66⅛ x 93½ in

50

designer
David Harlan

college
California Institute of
the Arts

country of origin
USA

work description
Sketch for an information
system

dimensions
279 x 216 mm
11 x 8½ in

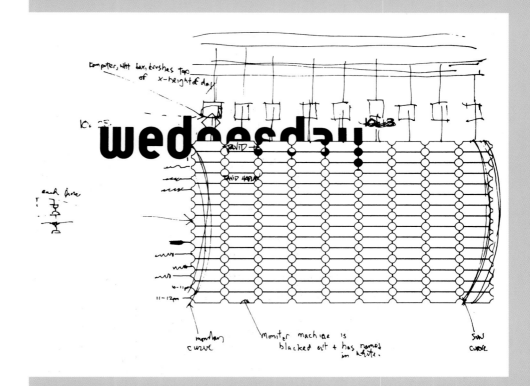

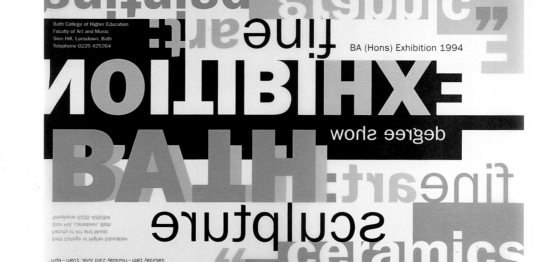

52

designer
Chris Roberts

college
Bath College of Higher
Education

country of origin
UK

work description
Front and back of a
double-sided degree show
poster, on tracing paper,
for Bath College

dimensions
594 x 420 mm
23⅜ x 16½ in

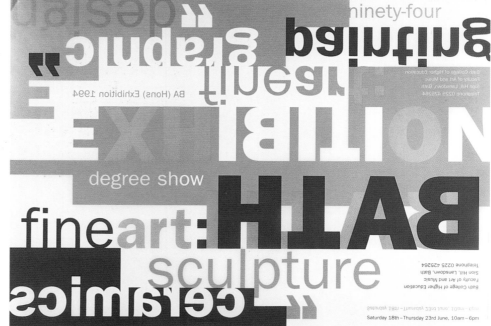

designer
Chris Roberts

college
Bath College of Higher
Education

country of origin
UK

work description
Lecture poster

dimensions
600 x 450 mm
23⅝ x 17¾ in

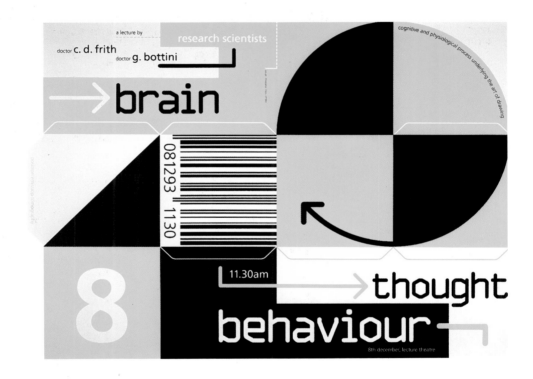

designer
Jörg Herzog

art director
Jörg Herzog

design company
Herzog Grafik und Design

country of origin
Germany

work description
Pages from a calendar

dimensions
420 x 594 mm
16½ x 23⅜ in

54

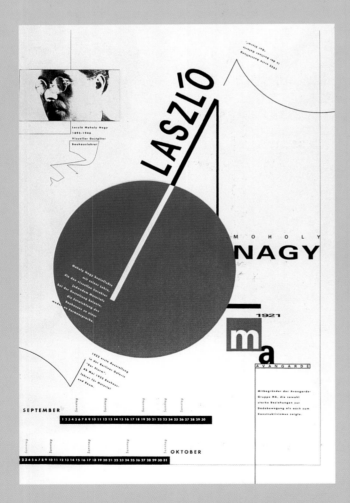

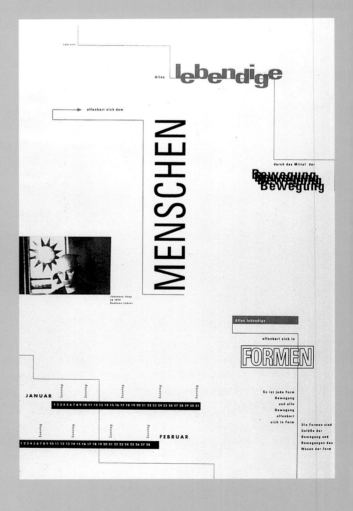

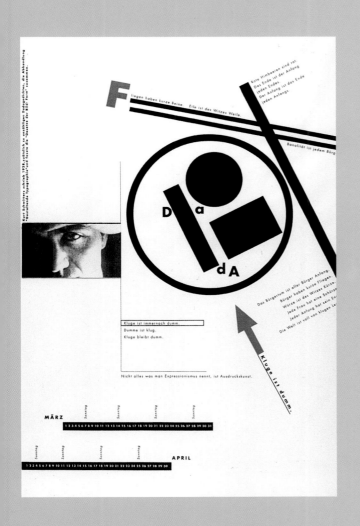

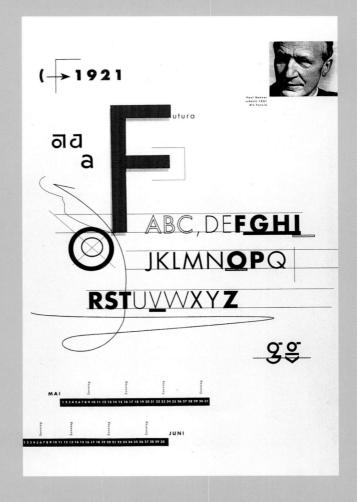

left and below

designer
Hans P. Brandt

design company
Total Design

country of origin
The Netherlands

work description
Front cover and spread
from the 1993 Annual
Report for Internationales
Design Zentrum, Berlin

dimensions
210 x 297 mm
8¼ x 11¾ in

right

designers
Weston Bingham
Chuck Rudy

design company
Deluxe

country of origin
USA

work description
Stationery for Deluxe
design company

dimensions
letterhead
215 x 280 mm
8½ x 11 in

deluxe envelope
30 St Felix Street #2D
Brooklyn NY 11217
30 Saint Felix Street number 2D
deluxe Deluxe!
 Adeluxe?
 deluxe deluxe***
 deluxe

05en
v.001

01,021h
v.001

06bc
v.001 30 Saint Felix Street number 2D
 30 St Felix Street #2D
 Brooklyn NY 11217

 xDeluxe! Weston Bingham
 deluxe deluxe Chuck Rudy
 deluxe*** 718 403 9801
 or 718 522 5457
 deluxe

Delux
C20 St Felix Street 2D
61 718 522 5457.

 Bdeluxe!
 Deluxe!
 deluxe***
 30 Saint Felix Street number 2D
 30 St Felix Street #2D
 Brooklyn NY 11217

 deluxe
 Weston Bingham
 Chuck Rudy
 718 403 9801
 or 718 522 5457

designer
Neil Fletcher

design company
Pd-p

country of origin
UK

work description
Peaches and Cream, a
poster for Sheffield
Hallam University Union
of Students

dimensions
594 x 840 mm
5½ x 7⅛ in

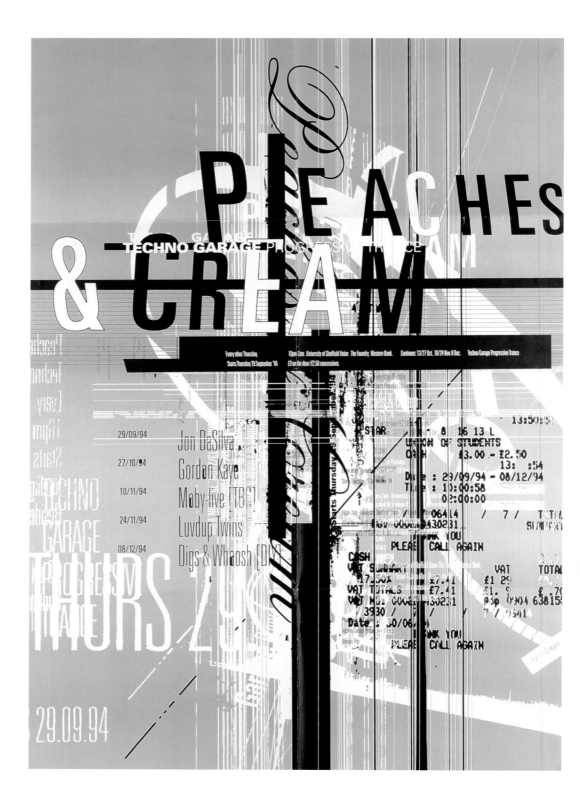

designers
Elisabeth Charman
Edwin Utermohlen

art directors
Elisabeth Charman
Edwin Utermohlen

design company
doubledagger

country of origin
USA

work description
Poster for the Herron
Gallery (unpublished)

dimensions
250 x 320 mm
9⁷⁄₈ x 12⁵⁄₈ in

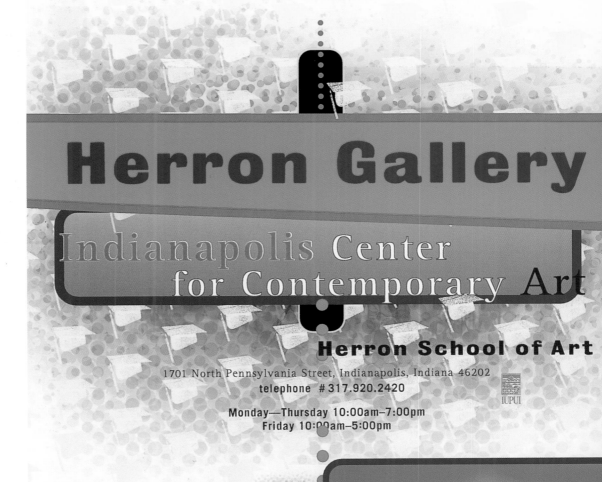

Herron Gallery

Indianapolis Center for Contemporary Art

Herron School of Art

1701 North Pennsylvania Street, Indianapolis, Indiana 46202
telephone # 317.920.2420

Monday—Thursday 10:00am—7:00pm
Friday 10:00am—5:00pm

IUPUI

FACULTY SHOW
(Part 2)

DATES: FEBRUARY 3—MARCH 10
1995

STUDENT SHOW[S]
MARCH 17—APRIL 7 + APRIL 14—MAY 5, 1995

designers
Laura Lacy-Sholly
James Sholly

design company
Antenna

country of origin
USA

work description
Front cover and spreads
from the *Indiana Civil
Liberties Datebook*, an
educational tool for the
Indiana Civil Liberties
Union with the theme
"Who Decides?"

dimensions
140 x 180 mm
5½ x 7⅛ in

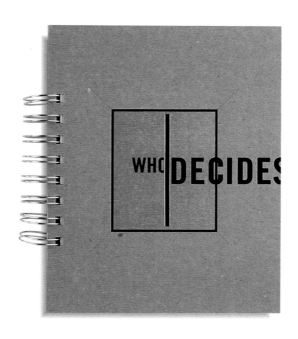

BEGIN HERE.

[CLEAN SLATE]

JULY 1995

MON 31 I wish that women, instead of being walking show-cases, instead of begging of the
Sanna Yoder fathers and brothers the latest and gayest new bonnet, would ask of them their rights.
 — Lucy Stone

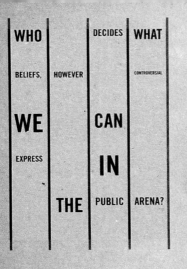

WHO DECIDES WHAT

BELIEFS, HOWEVER CONTROVERSIAL

WE CAN

EXPRESS IN

THE PUBLIC ARENA?

DEAR FRIEND OF THE INDIANA CIVIL LIBERTIES UNION,

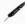

There's something inspiring about a new calendar:
365 blank spaces, all of them awaiting your plans,
aspirations and activities. . .

the promise of a fresh year and the chance
to spend time more wisely.
(Or at least to try.)

I think there's something awe-inspir-
ing about this new calendar. While it cer-
tainly will tell you what date to write at the
top of your checks, the 1991 ICLU Datebook
is so much more. It's a repository of wise
words. It's a gathering of friends. It's a
hard-working fundraiser. Most of all, it's a
labor of love.

We're thrilled that you've chosen to
make this book a part of your new year. We
hope that you'll take the time to explore all
that it holds. Notice the many bits of wis-
dom, two on each week, from the creative

thinkers and civil libertarians of the last
few centuries. Deep in February—when
you cannot rise to one more stark, gray
day—just open your datebook. Oscar
Wilde's commentary on truth will give you
a jump-start.

Your new calendar brings together
friends from around the state. Hoosiers of
all ages and persuasions have given both the
time and financial resources to make this
project possible. Many have teamed up
with colleagues to underwrite particular
dates. Others have worked on producing
the book. Still others apply themselves
behind-the-scenes preserving and promot-
ing the ideas represented in these pages.

AUGUST

M O
T H
E R

Who decides the value of the maternal link?

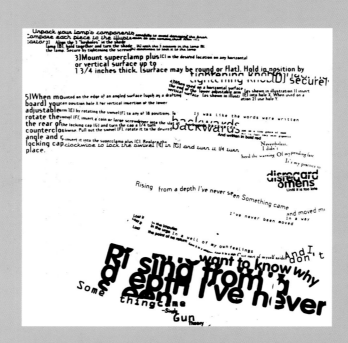

designer
Shelley Stepp

college
California Institute of
the Arts

62

country of origin
USA

work description
Typographic assignments
based on poetic and
didactic texts

dimensions
254 x 254 mm
10 x 10 in

designer
Shelley Stepp

college
California Institute of
the Arts

country of origin
USA

work description
Studies with identical
texts – the changing
forms create new
meanings

dimensions
762 x 762 mm
30 x 30 in

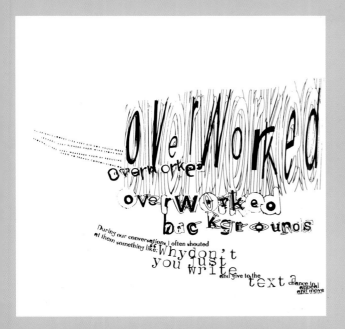

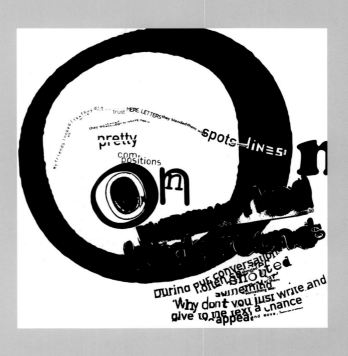

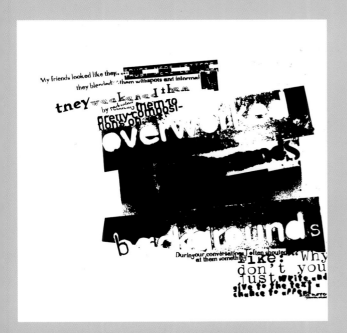

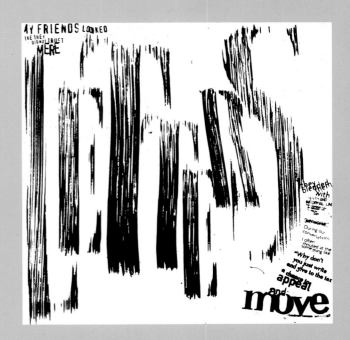

designer
Jan C. Almquist

art directors
Jan C. Almquist
Hans-U. Allemann

design company
Allemann Almquist &
Jones

country of origin
USA

work description
Front cover of
A Compelling Argument,
a brochure for the
Winchell Company,
printers

dimensions
158 x 292 mm
6¼ x 11½ in

From concept

designers
Stephen Shackleford
Jan C. Almquist

art directors
Jan C. Almquist
Hans-U. Allemann

design company
Allemann Almquist &
Jones

country of origin
USA

work description
Front cover of *From
Concept to Result*, a
brochure for the Winchell
Company, printers

dimensions
158 x 292 mm
6¼ x 11½ in

65

designer
Christopher Ashworth

design company
Invisible

country of origin
UK

work description
Letterhead for Shaun
Bloodworth; designed for
a typewriter with a wide
carriage

dimensions
297 x 210 mm
11¾ x 8¼ in

Shaun Bloodworth 4d Adolphus Road London N4 2AZ

T 081 809 6564

Shaun

BLOODWORTH

Tel **0** **81**

809 6 5 **64**

081 8 0 9 65 6 4

Shaun Bloodworth

T **081 809 6564** 4d Adolphus Road
London
N4 2AZ

Se

by **Eg G**

designer
Jeremy Francis Mende

college
Cranbrook Academy of
Art, Michigan

country of origin
USA

work description
Dada Invoice

dimensions
203 x 254 mm
8 x 10 in

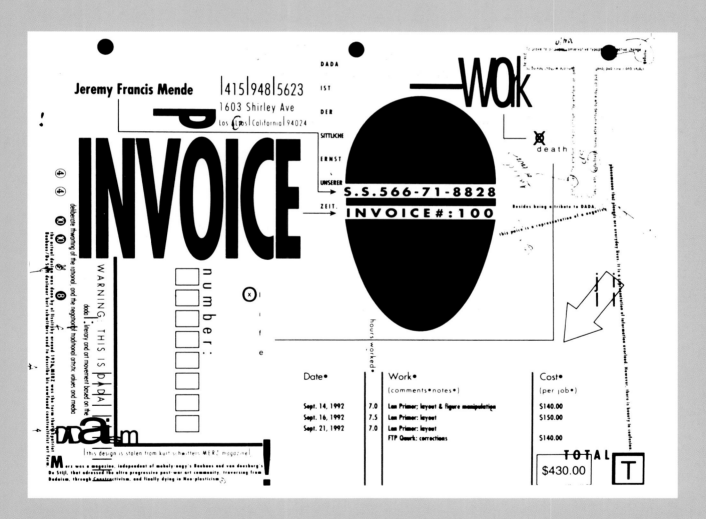

designer
Christopher Ashworth

design company
Orange

art director
Christopher Ashworth

country of origin
UK

work description
Three flyers from a set of
four, for Libido Nightclub

dimensions
right and far right
206 x 99 mm
8⅛ x 3⅞ in
far right, below
130 x 130 mm
5⅛ x 5⅛ in

68

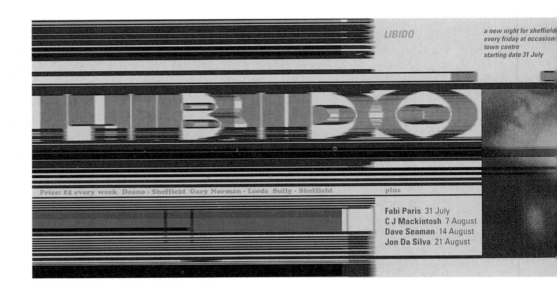

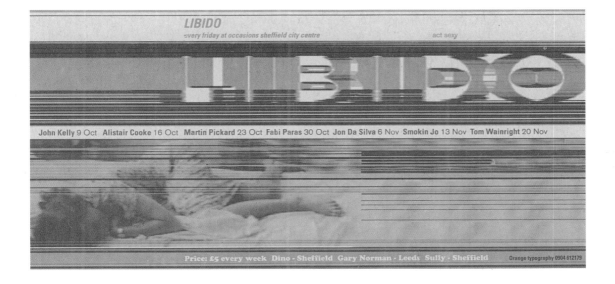

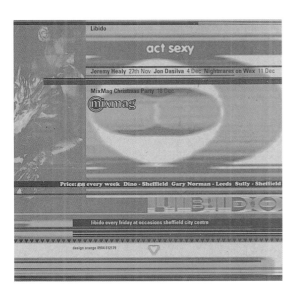

designer
John O'Callaghan

college
Ravensbourne College
of Design and
Communication,
Chislehurst

tutor
Paul Elliman

country of origin
UK

work description
Spreads from a project
responding to media
representation of the
Gulf War

dimensions
420 x 594 mm
16½ x 23⅜ in

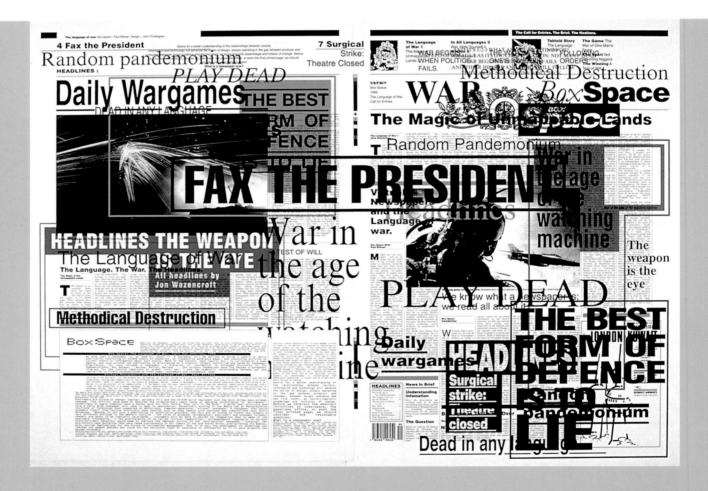

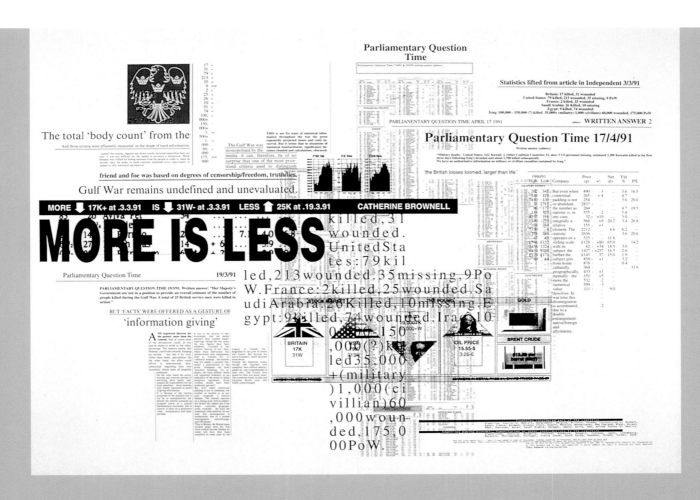

The total 'body count' from the

Gulf War remains undefined and unevaluated.

MORE IS LESS

Parliamentary Question Time

Parliamentary Question Time

Statistics lifted from article in Independent 3/3/91

Parliamentary Question Time 17/4/91

CATHERINE BROWNELL

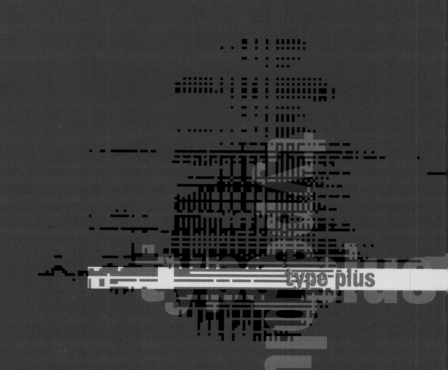

type plus

type plus

type plus

designers
Simon Taylor
Dirk van Dooren

design company
Tomato

country of origin
UK

work description
Promotional photographs
for Urban Reaction
Clothing Label, Japan

dimensions
51 x 76 mm
2 x 3 in

74

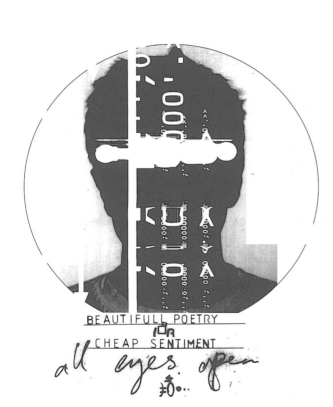

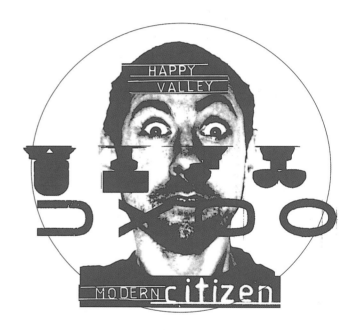

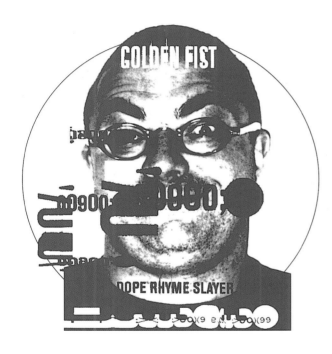

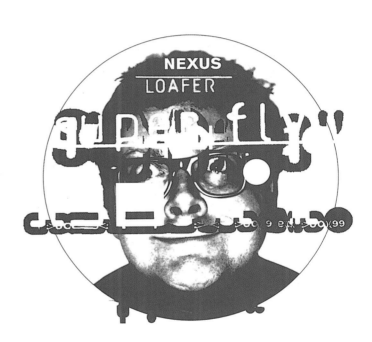

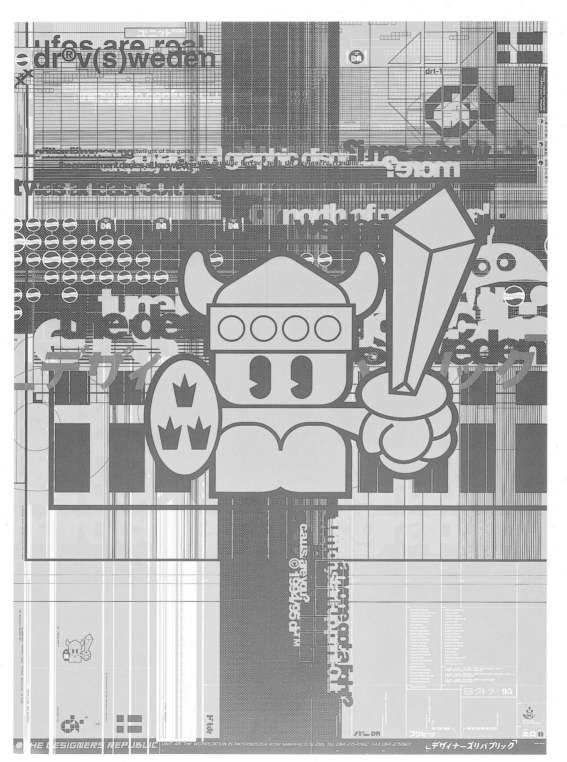

76

left

designer
The Designers Republic

country of origin
UK

work description
*The Designers Republic
vs the Entire Population
of Sweden*, a self-
promotional poster

dimensions
297 x 420 mm
11¾ x 16½ in

right
designer
Dirk van Dooren

art director
Trichett & Webb

design company
Tomato

country of origin
UK

work description
Page from a self-promotional
calendar

dimensions
325 x 410 mm
12¾ x 16⅛ in

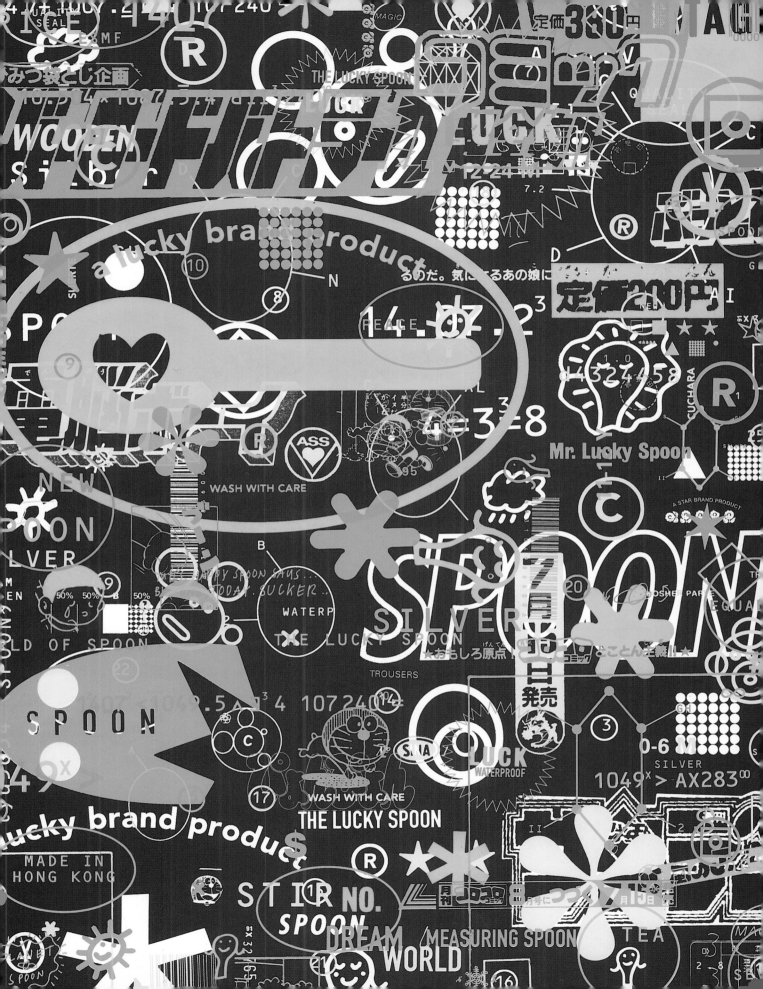

designers
Heather Ferguson
Amy Jo Banton

photographers
Heather Ferguson
Amy Jo Banton

art directors
Heather Ferguson
Amy Jo Banton

design company
2 Bellybuttons

country of origin
USA

work description
Front cover and spread
from the magazine *Flying
the Coupe*

dimensions
253 x 305 mm
10 x 12 in

78

H: how were the mounds discovered? I mean how did they discover the mounds? W: the mounds here? H: yeah W: they're pretty evident H: they are? W: you got one out there that's 70, over 70 feet high H: wow W: so i mean you're gonna stumble over them H: yeah AJ: (laughter) W: the mounds have been known, they were first reported in the 1860's, 1870's H: uh-huhh W: like the ridges were not discovered until the 1950's, when this aireal view photograph was found H: oh W: here were some people working there. they knew they had a huge site H: yeah W: but, ahh, they were digging on mound B over that, that a way. and. and, ahhh, James Ford from the American Museum of Natural History went over to Vicksburg Waterways experimental station and he got and he found this photograph, W RIDGES!! and you can see them. Actually this earlier photograph shows them but no one ever noticed H: they just dic odd that there was another indian hill and um, there you are (AJ has finally located subject with view camera subdivision around it W: okay , north of Monroe ? AJ & H: yeah W: yeah, that's Frenchman's Bend and, ah, that w W: and, ah, it was very exciting and they're not destroying it. they're just kind of working around it and they're gonna mounds will be part of the golf course AJ: oh really W: uh huh AJ: wow H: (laughter) W: yeah the developer there has been very, very responsible and it's really great to have some one like that AJ: yeah, we saw it, we saw it yesterday. it was, it just seems really strange, usually they, you know, usually, like in Virginia they would just, like, put up, ah, you know, i don't know, sort of like a place. they would put up a whole monument around it and everything W: well we have too many of them AJ: oh really W: yeah if you were to do that with every indian site, you would have problems AJ: yeah W: and, ah, further more, the state doesn't have the money to do it, so... AJ: so why don't they just excavate them and... W: all right what happens when you excavate a site? AJ: everybody gets all up in a uproar. i don't know about moving the artifacts W: no, stop and think. when you've excavated a site, what happens to that site? H: it's been destroyed W: so therefore, the best thing to do on a site is to excavate enough to find out what you need know and then leave, because techniques change H: yeah W: ah, i went on my first dig in 1955 H: wow W: an the differences in the way digs are done then and now are just incalcuable H: uh huh W: the different techniques and everything else from what we've been able to find H: yeah W: ah, see i was digging in the southwest about the time they were finding that photograph H: wow W and ah, so as a result, no you don't want to dig them H: you destroy them W: no you want to preserve them by putting a golf course on it it's perfectly preserved H: yeah W: what's going to happen? you're going to mow the grass. H: (laughter) AJ: yeah but don't you think all these unknowns will try to excavate themselves? W: no AJ: you don't think so! H: (laughter) W: because all the local pot hunters know that there's nothing in there worth it H: yeah W: i mean it's that site okay, the type of material that's in that site is microflint, they found one or two poin and they found lots of fire-cracked rock which is really something H: yeah AJ & H: (laughter) W: it's nothing to write home to mother about, so th

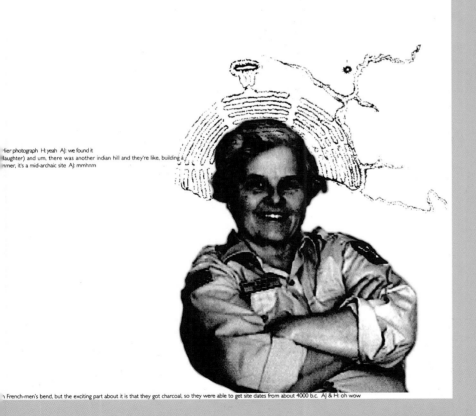

rlier photograph H: yeah AJ: we found it
laughter) and um, there was another indian hill and they're like, building a
nmer, it's a mid-archaic site AJ: mmhnm

n French-men's bend, but the exciting part about it is that they got charcoal, so they were able to get site dates from about 4000 b.c. AJ & H: oh wow

below

designers
Paula Benson
Paul West

photographer
Spiros

art directors
Paula Benson
Paul West

design company
Form

country of origin
UK

work description
Spread from a press
release in the form of a
mini newspaper, for 2WO
THIRD3

dimensions
294 x 415 mm
11⅝ x 16⅜ in

right

designers
Paula Benson
Paul West

photographers
above
Lawrence Watson
below
Tim Platt

art directors
Paula Benson
Paul West

design company
Form

country of origin
UK

work description
I Want the World and *Ease
the Pressure*, open CD
boxes for 2WO THIRD3

dimensions
140 x 125 mm
5½ x 5 in

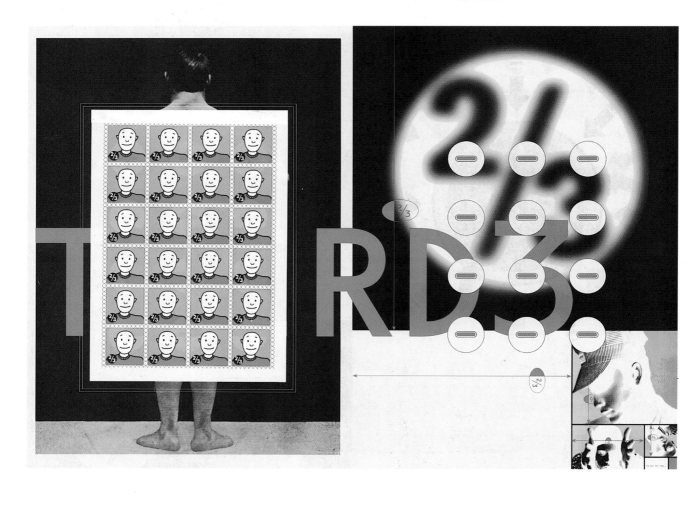

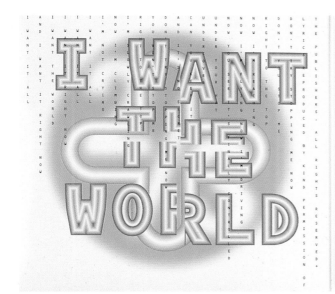

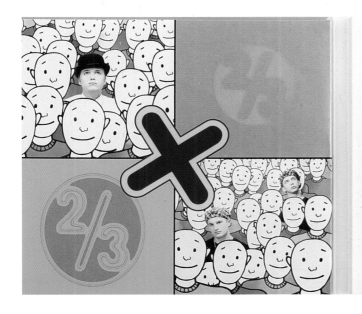

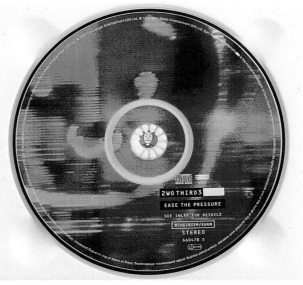

Columbia University
Graduate School of Architecture Planning and Preservation

Introduction to Architecture

A Summer Studio in New York

designer
Willi Kunz

photographers
right
Skyviews
far right
Richard Plunz

design company
Willi Kunz Associates

82 **country of origin**
USA

work description
Program posters for
Columbia University,
Graduate School of
Architecture, Planning,
and Preservation, New
York

dimensions
305 x 609 mm
12 x 24 in

A summer program giving university credit which introduces the student to aspects of the design, history, theory, and practice of architecture. The program is intended both for those without previous academic experience in design who are interested in architecture as a potential career, and for those with previous experience in architectural design who would like to develop additional studio design skills, perhaps in preparation for application to graduate school.

Courses are given in the studios of Avery Hall, home of Columbia University's world-renowned Graduate School of Architecture, Planning, and Preservation, on the Morningside Heights campus in New York City. Studios and seminar courses are taught by experienced architects and designers, coordinated and supervised by members of the faculty of the Graduate School. For those who may require it, housing is available on the University campus, with direct access to Avery Hall.

Students attend classes four days a week for five weeks, both morning and afternoon sessions. In the morning session, students are introduced to the fundamentals of architectural history and theory, structures, technology, and professional practice. Also, this course will introduce the student to the extraordinary city of New York, with its world famous collection of museums, cultural institutions, and architectural monuments. Lectures, seminar presentations, tours of architect's offices, and field-trips to active building sites, museums, and famous works of architecture in New York City are led by the instructors.

In addition, students will attend a series of special lectures to be given by distinguished and renowned architects, including the following:

Kenneth Frampton
Architect; professor; author of "Modern Architecture: A Critical History"

Steven Holl
Architect; professor; winner of numerous Progressive Architecture Awards

James Stewart Polshek
Architect; professor; designer for the renovation of Carnegie Hall

Robert A. M. Stern
Architect; professor; author of "Pride of Place"

Bernard Tschumi
Architect; Dean, Columbia University; designer of the park "La Villette", Paris

In the afternoon, the students attend the design studio – an educational method unique to architecture – a place where students are given an intensive training in the skills and critical thinking involved in architectural design. Students, in small groups, work directly with studio instructors to develop their individual design, which the students then present in periodic reviews or "juries", where they hear the comments and criticism of the invited architects and professors. The design projects given in studio are frequently situated in New York City, so that the student is able to apply the knowledge he or she has gained from the morning sessions. The development of supporting skills such as drawing and model-building is also included in the studio curriculum.

Together the studio and lectures present a comprehensive introduction to every aspect of architecture as it is practiced today. In addition, through the various field-trips and tours, the student learns from the extraordinary examples of architectural and urban design in New York City, the world's preeminent center for architectural culture.

Program Director:
Thomas Hanrahan,
Architect; professor

Introduction to Architecture:
July 6 to August 8
Monday, Tuesday, Wednesday, Thursday
10:00am-5:00pm
3 credits, studio and seminar
Tuition for 1992: $1590
Housing on the Columbia University campus (if required): approximately $800

Applications should include a transcript of the applicant's academic record; a resume summarizing education, employment, and other types of experience; and, where appropriate, examples of the applicant's design work. Also please include a $35 application fee (checks made out to: Columbia University).

Applications are due by June 30

For information and applications write or call:

Office of Admissions – Introduction to Architecture Program Columbia University Graduate School of Architecture, Planning, and Preservation 400 Avery Hall New York, NY 10027 (212) 854-3414

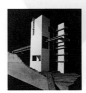 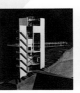 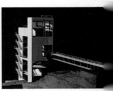

Master of Science in Architecture and Urban Design

The Master of Science Degree in Architecture and Urban Design is an intensive three semester program for architects interested in post-professional design specialization.

Program
The curriculum is oriented toward the emerging urbanism in the United States, with a particular emphasis on the situation in New York City. It seeks to define parameters and problems which will carry into the next century. It also embraces a special relationship between the design studio and New York, through collaboration with city agencies and other public interest constituencies. Comparative study with other world cities is also considered central to the pedagogic structure, focused on seminars and case studies.

Emphasis
The degree is intended to augment traditional professional training in architecture for those who wish to further investigate the physical aspects of urbanism. "Urban Design" is seen as an activist, social art: more than a singular representation of physical scale, the term defines a commitment to discourse at all scales of design activity. The design studio is the primary catalyst for the curriculum, centered on a highly individualized, atelier approach. The unique situation of Columbia allows New York City to become a laboratory, in which the discipline of architecture can be applied to a myriad of problems within our urban environment at all scales of inquiry. At the same time, the more theoretical component of coursework allows for comparative study with other world cities and situations. The final studio affords an opportunity for comparative study between New York and another world city.

Resources
The Columbia University Graduate School of Architecture, Planning and Preservation is a unique academic forum within which to pursue studies in Urban Design. The distinguished, multidisciplinary faculty nurtures a wide-ranging critical perspective on the question of urbanism today. Classroom and studio teaching is reinforced by extensive lecture and publication programs. The Avery Architectural and Fine Arts Library is an invaluable resource, as the nation's finest repository for the literature of architecture, planning, and fine arts. In addition, the innumerable cultural resources of New York City, as a whole, are close at hand.

Bernard Tschumi, Dean
Richard Plunz, Director

Further information and application:
Columbia University
Office of Architecture Admissions
400 Avery Hall
New York, NY 10027
212 854 3414

Urban Design

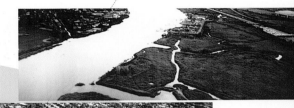

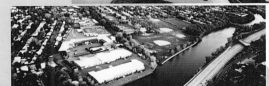

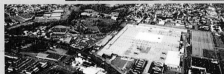

designer
David de Jong

photographers
Jurjen de Jong
David de Jong

college
Utrecht School of
the Arts

country of origin
The Netherlands

work description
Box lid (below, left), open
box (below, right) and
spreads (far right) from
An Interactive Book; texts
are linked by symbols and
numbers which allow the
book to be read in several
directions (unpublished)

dimensions
box size
345 x 345 mm
13⅝ x 13⅝ in

What is painting?
Well, it is literature.
What is literature then?
Well, it is demotion?
The rest is demotion.
What is the rest?
Like the moon when she is full.
When she is a slender crescent,
When she is black theoretical night.

The principle of doubt serves as the common factor, the vanishing point, behind Duchamp's pseudo-paradoxical, constantly reversible principles: chance and precision are not the only incompatibles that he reconciles. His conviction of the absence of purpose and meaning in existence goes from the freedom to concentrate on the most abstract art' useless' distinctions and nuances, and to enter a realm in which not even the conventional categories of visibility and invisibility remain valid.

I doubt the word to be.

Un coup de des: jamais n'abolira le hasard

Wat is een gebaar?

Wat is een gebaar? Iets als de aanvulling van een handeling. De handeling is transitief, zij wil alleen een object, een resultaat doen ontstaan; een gebaar is de onbepaalde en onuitputtelijke som van nemen, drijfveren, van lakendoen de de handeling met een atmosfeer (in de sterrenkundige zin van het woord) omgeven.

We moeten een onderscheid maken tussen de boodschap, die informatie wil geven, het teken, dat begrip wil wekken, en het gebaar, dat al het overige produceert (de 'aanvulling') zonder noodzakelijkerwijze iets te willen produceren. De kunstenaar [...] is uit de aard der zaak een maker van gebaren: hij wil een effect bewerkstelligen en wil dat terzelfdertijd niet; de effecten die hij bewerkstelligt zijn niet noodzakelijkerwijze de welke hij heeft beoogd; het zijn omgekeerde, op hun kop gezette, losgebroken effecten, die op hemzelf terugvallen en vanaf dat moment leiden tot wijzigingen, afwijkingen, tot het vager worden van het spoor. Zo is in het gebaar het onderscheid tussen oorzaak en gevolg, motivatie en doel, uitdrukking en overreding verdwenen.

Wat zij bekijken wordt vervangen door
ideeën die hun interessant lijken,
zodoende kennen zij het mysterie niet
dat door dit denken wordt opgeroepen.

ideografie', v. (schrift waarin
de tekens begrippen weergeven
[en niet, als bij ons, klanken];
oorspr. b.v. de hieroglyfen)

designers
Carlo Tartaglia
Robert Lamb

college
Ravensbourne College
of Design and
Communication,
Chislehurst

tutor
Rupert Bassett

country of origin
UK

work description
Cover and spreads from
the 1993 Ravensbourne
College degree show
publication

dimensions
297 x 420 mm
11¾ x 16½ in

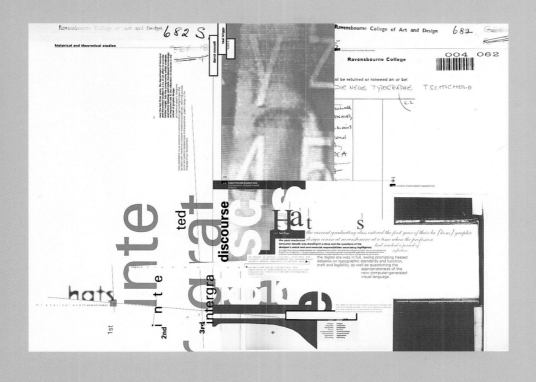

designer
The Designers Republic

country of origin
UK

work description
Tournesol by Kokotsu, LP
(R & S Records, Belgium);
center of gatefold sleeve

dimensions
430 x 310 mm
16⅞ x 12¼ in

designer
The Designers Republic

photographers
Phil Wolstenholme
Jess Scott-Hunter
David Slade

country of origin
UK

work description
Artificial Intelligence II,
compilation LP (Warp
Records, UK); center of
gatefold sleeve

dimensions
430 x 310 mm
16⅞ x 12¼ in

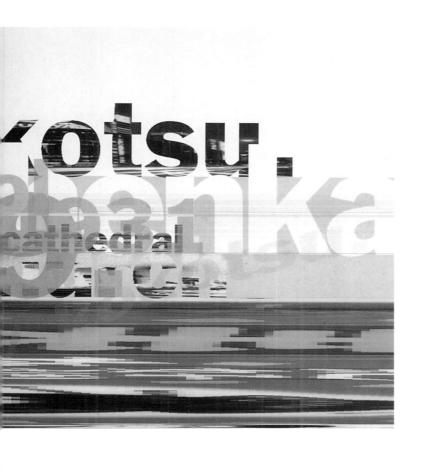

designer
Iain Cadby

country of origin
UK

work description
Two self-published
posters, from a set of
three

dimensions
210 x 297 mm
8¼ x 11¾ in

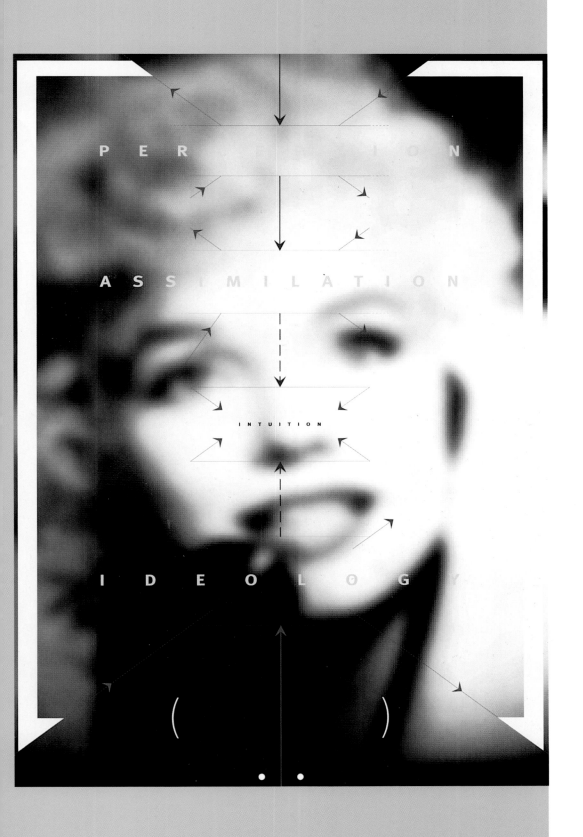

PER CEP TION

ASS I MILATION

INTUITION

IDEOLOGY

()

designer
Irma Boom

photographer
Aero photo Schiphol bv

design company
Irma Boom

country of origin
The Netherlands

work description
Telephone cards, with
their reverse images (far
right) combined to form a
picture

dimensions
shown actual size
85 x 54 mm
3⅜ x 2⅛ in

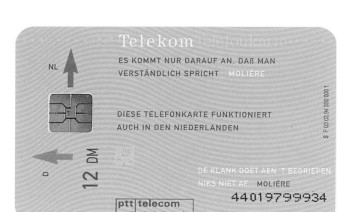

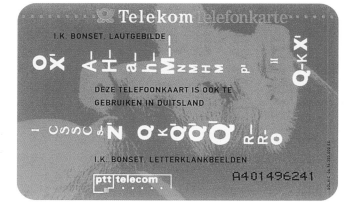

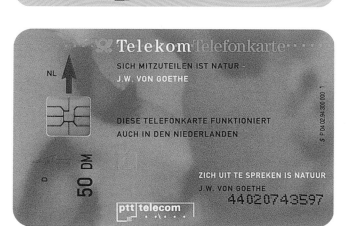

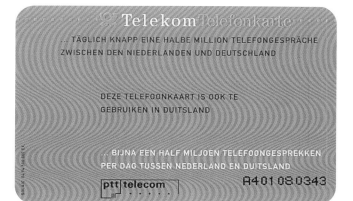

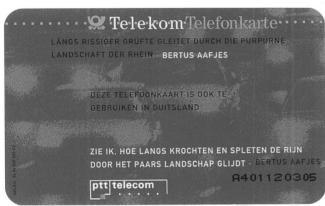

LÄNGS RISSIGER GRÜFTE GLEITET DURCH DIE PURPURNE
LANDSCHAFT DER RHEIN · BERTUS AAFJES

DEZE TELEFOONKAART IS OOK TE
GEBRUIKEN IN DUITSLAND

ZIE IK, HOE LANGS KROCHTEN EN SPLETEN DE RIJN
DOOR HET PAARS LANDSCHAP GLIJDT · BERTUS AAFJES

ptt telecom

A401120305

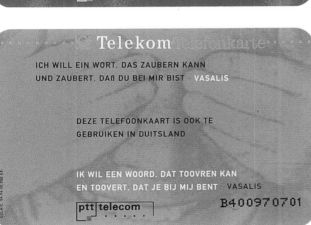

ICH WILL EIN WORT, DAS ZAUBERN KANN
UND ZAUBERT, DAß DU BEI MIR BIST · VASALIS

DEZE TELEFOONKAART IS OOK TE
GEBRUIKEN IN DUITSLAND

IK WIL EEN WOORD, DAT TOOVREN KAN
EN TOOVERT, DAT JE BIJ MIJ BENT · VASALIS

ptt telecom

B400970701

designer
Brad Trost

photographer
Kurt Hettle

art director
Brad Trost

design company
doubledagger

country of origin
USA

work description
Promotional postcard for
Herron Photo Lab

dimensions
195 x 126 mm
7³⁄₅ x 6 in

94

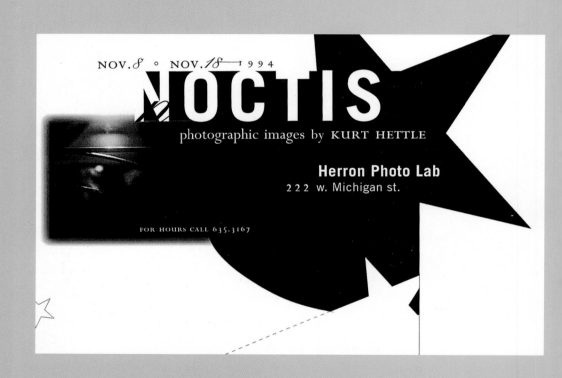

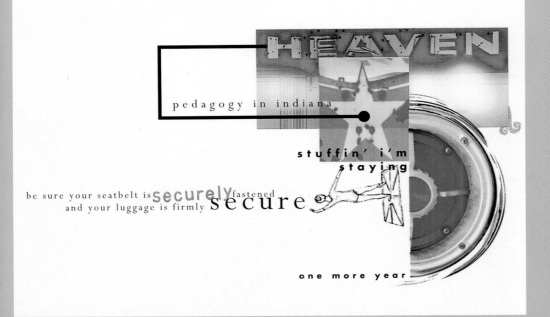

Gold Star Heaven

HEAVEN

pedagogy in indiana

stuffin' i'm
staying

be sure your seatbelt is securely fastened
and your luggage is firmly secure

one more year

designer
Elisabeth Charman

photographer
Elisabeth Charman

art director
Elisabeth Charman

design company
doubledagger

country of origin
USA

work description
Gold Star Heaven, a self-
promotional postcard

dimensions
152 x 102 mm
5 x 4 in

95

designer
Mark Hough

art director
Jane Kosstrin-Yurick

design company
Doublespace

country of origin
USA

work description
Poster for the Dartmouth
College Conference

dimensions
580 x 430 mm
22⅞ x 16⅞ in

96

designer
Chris Myers

photographer
Chris Myers

art director
Nancy Mayer

design company
Mayer & Myers

country of origin
USA

work description
Lecture poster, for The
American Institute of
Graphic Arts, Philadelphia,
and the University of the
Arts, Philadelphia

dimensions
482 x 482 mm
19 x 19 in

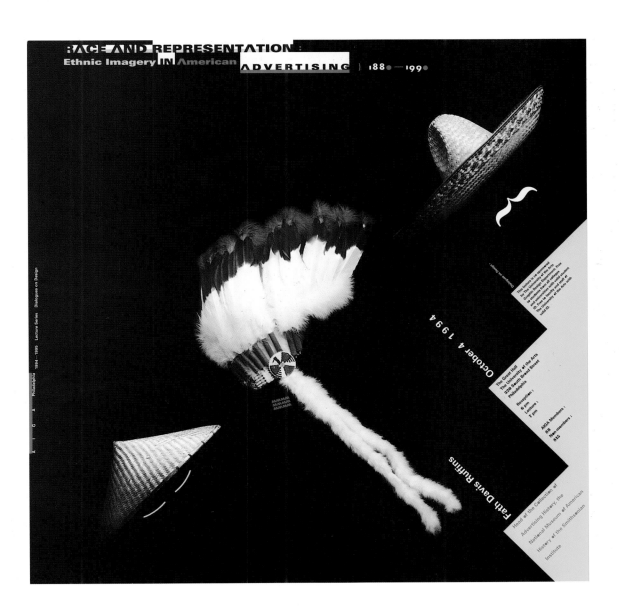

designers
Stephanie Krieger
Maximilian Sztatecsny

photographer
right
Margherita Spiluttini

art director
Stephanie Krieger

design company
Krieger/Sztatecsny

country of origin
Austria

work description
Front covers of two
architecture booklets for
Architektur Zentrum Wien

dimensions
150 x 298 mm
5⅞ x 11¾ in

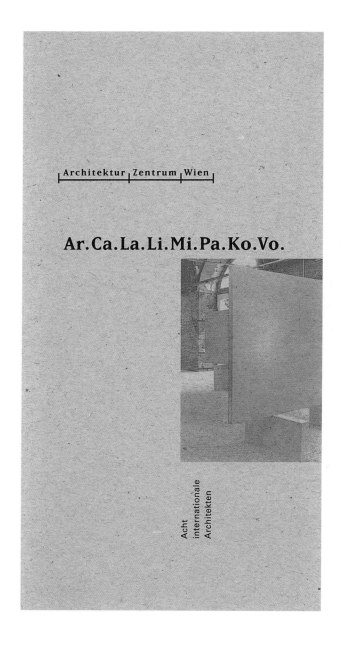

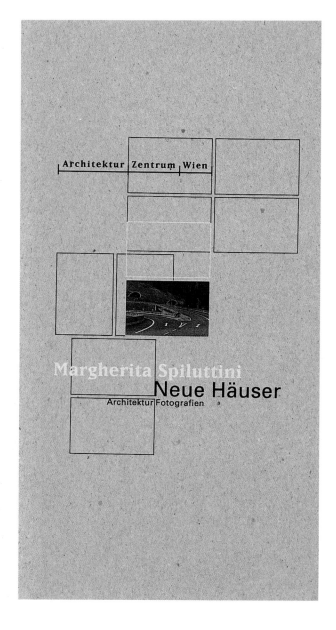

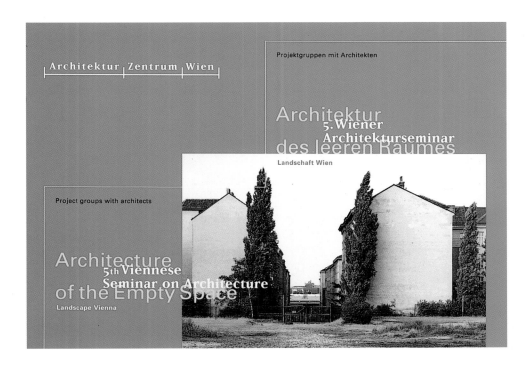

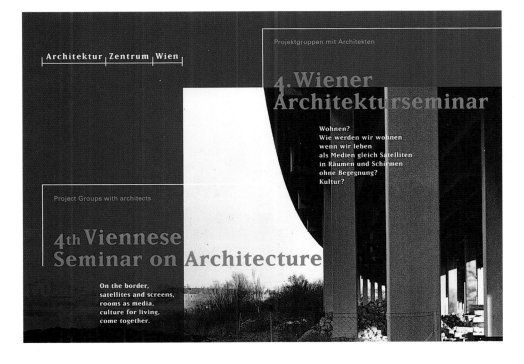

designer
Stephanie Krieger

photographer
Johannes Faber

art director
Stephanie Krieger

design company
Krieger/Sztatecsny

country of origin
Austria

work description
Spreads from leaflets
announcing the fourth
and fifth Viennese
Seminars on Architecture,
for Architektur Zentrum
Wien

dimensions
210 x 148 mm
8¼ x 5⅞ in

99

designers
Christopher Ashworth
Amanda Sissons
Neil Fletcher
John Holden
Dave Smith

photographer
John Holden

art director
Christopher Ashworth

design company
Invisible

country of origin
UK

work description
Jacket of *Interference*,
a book exploring the
dehumanizing and
sinister effects of security
surveillance in the city,
published by Ümran
projects

dimensions
668 x 290 mm
26¼ x 11⅜ in

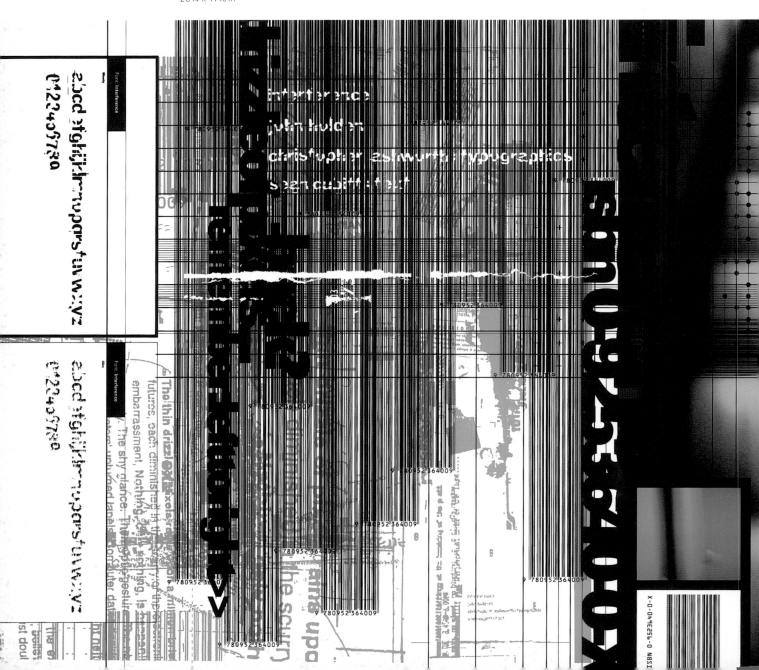

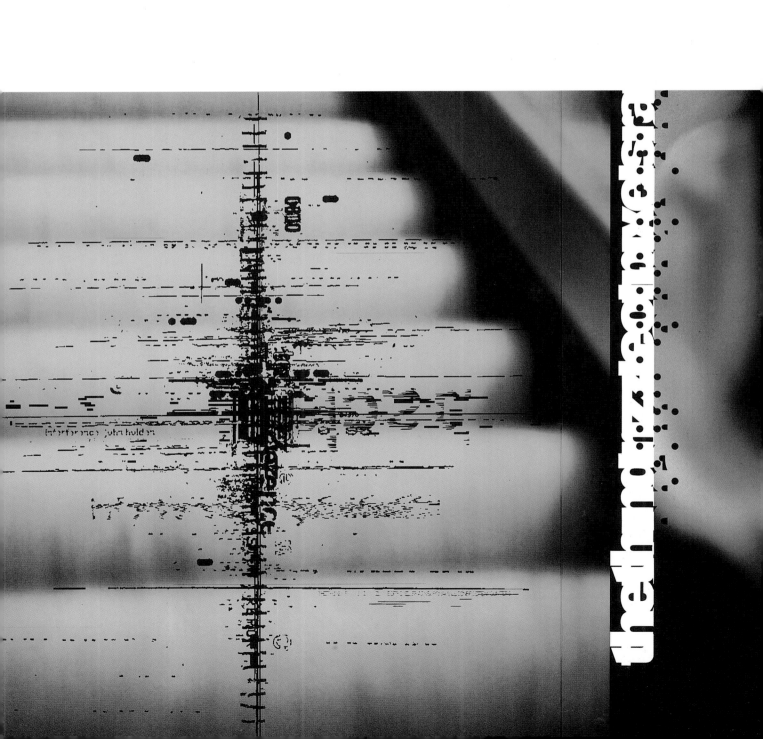

designer
Naomi Mizusaki

photographer
Jennifer Lynch

art directors
Drew Hodges
Vincent Sainato
Elisa Feinman

design company
Spot Design

country of origin
USA

work description
Box (left) and spreads
from a sci-fi channel
marketing planner; the
spreads are interleaved
with sheets of translucent
red gel which obscure
areas of the graphics or
words to create additional
messages

dimensions
299 x 171 mm
11¾ x 6¾ in

102

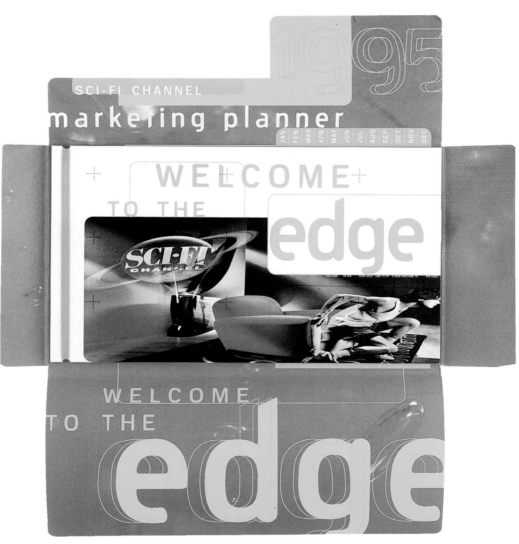

BLASTING OFF

The Sci-Fi Channel is the interstellar source for a most diverse mix of science fiction entertainment. All Sci-Fi Channel offerings are suitable for family viewing, appealing to viewers of all ages – men, women, teens, kids, general viewers and intense sci-fi fans!

Cable subscribers turn to the Sci-Fi Channel for inventive science fiction fare they can't find anywhere else in the galaxy.

Sci-Fi Channel Planetary Premieres

Never before-seen original movies, developed exclusively for the Sci-Fi Channel. Future titles include The Companion, the tale of a male android who is humanized by a female novelist, and Trapped in Space, the story of a spaceship crew faced with certain death when their shuttle suffers a meteor strike. Planetary Premieres feature top talent like Donald Sutherland, Lisa Bonet and Stephen Baldwin.

Original Series

The Sci-Fi Channel presents original series produced exclusively for Sci-Fi. Inside Space is an informative series featuring fascinating glimpses into the incredible world of space travel. Sci-Fi Buzz is a behind-the-scenes magazine show with the scoop on sci-fi cinema, television series, books and more. Plus, a brand new Sci-Fi Channel original program joining the current craze for home shopping will offer weekly opportunities for sci-fi fans to purchase a wide variety of science fiction-related items.

Movies

Sci-Fi showcases superior science fiction cinema including box office hits Invasion of the Body Snatchers, Close Encounters of the Third Kind, Star Wars, The Empire Strikes Back, Return of the Jedi, Star Trek: The Motion Picture, Star Trek II, Star Trek IV, Star Trek V, Alien, Dune, and more! Special unedited versions and directors' cuts of classic and cult films are also shown.

Classic Series

Starting January 1, 1995, the Sci-Fi Channel proudly presents the quintessential sci-fi series: The Twilight Zone! Rod Serling's landmark program became instantly popular when it premiered in 1959, and its huge cult audience continues to grow. Plus Sci-Fi has acquired exclusive rights to all five seasons of the Emmy award-winning shows, which will be telecast in their original order, only on Sci-Fi!

Sci-Fi Channel favorites include Alien Nation, Beauty and the Beast, Quantum Leap, The Prisoner, Lost in Space, and Battlestar Galactica. More series sure to keep subscribers committed to cable are coming soon to Sci-Fi: Galactica 1980, The Six Million Dollar Man, Boris Karloff's Thriller, and She-Wolf of London.

Exclusive Extras

Behind-the-scenes specials reveal backstage glimpses of sci-fi titles like Wolf, Frankenstein, Star Trek, Jurassic Park and Bram Stoker's Dracula. Monthly theme movie weeks celebrate film genres and spotlight legendary sci-fi characters and personalities.

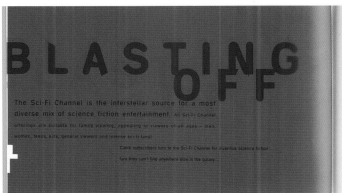

designers
Peter Dyer
Conor Brady

photographer
Michael Ormerod

design company
React

country of origin
UK

work description
Front and back covers of
the magazine *Cape*, issues
2 & 3

dimensions
274 x 362 mm
10¾ x 14¼ in

104

JOHN CHEEVER + R
SELL HOBAN + HARO
BRODKEY + DAVID
EFF + ANTHONY HE
ANDEZ + WHITNEY
LLIETT + LEE FRIED
NDER + BETH NUG
T + MICHAEL ORME
D + BOHUMIL HRAB

£5.00

CHARLES SPRAW
ON + YUKIO MIS
IMA + MICHAEL
'NEILL + ROBER
MAPPLETHORPE
COLM TÓIBÍN + L
NI RIEFENSTAHL
EIKO ISHIOKA +
HARON OLDS + H
ROLD BRODKEY +
ICHAEL COLLINS

£5.00

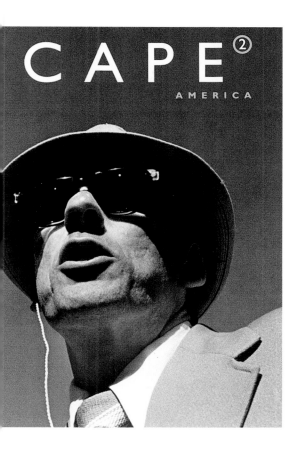

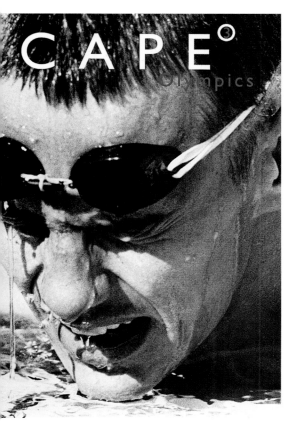

105

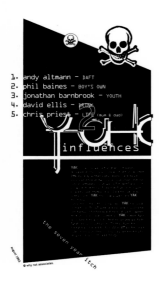

designers
this page
Jonathan Barnbrook
(above)
David Ellis (below)
opposite page
Andy Altmann (left)
Phil Baines (center)
Chris Priest (far right)

design company
Why Not Associates

country of origin
UK

work description
Yak 2, posters

dimensions
this page
762 x 508 mm
30 x 20 in
opposite page
508 x 762 mm
20 x 30 in

106

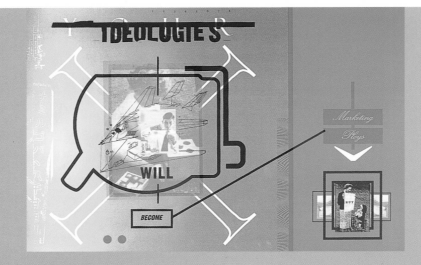

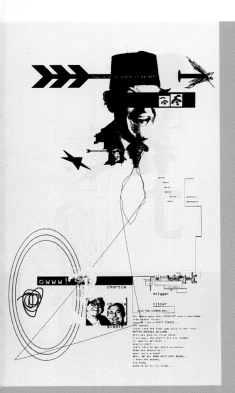

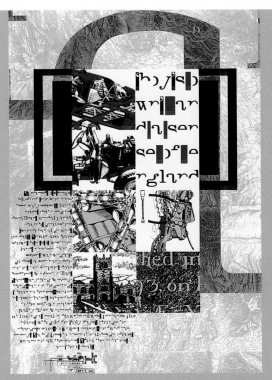

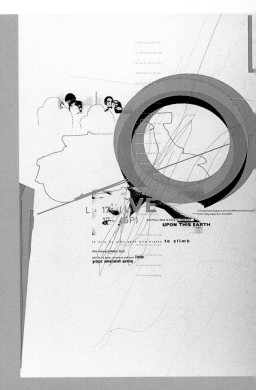

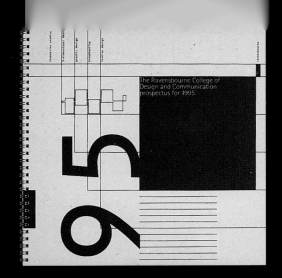

designers
Rupert Bassett
Paul Blackburn

photographer
Ringan Ledwidge

country of origin
UK

work description
Cover, spreads, and
pages from the 1995
catalog/prospectus for
Ravensbourne College
of Design and
Communication,
Chislehurst

dimensions
300 x 285 mm
11 7/8 x 11 1/4 in

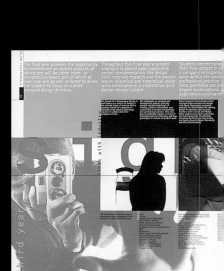

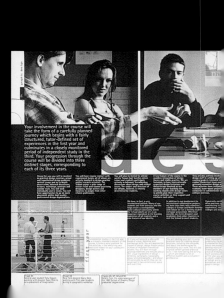

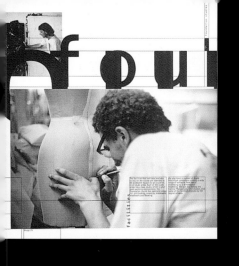

four

facilities

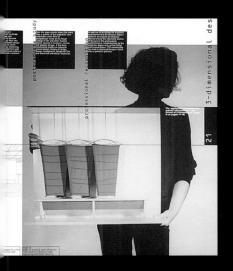

postgraduate study

professional recou...

3-dimensional des

21

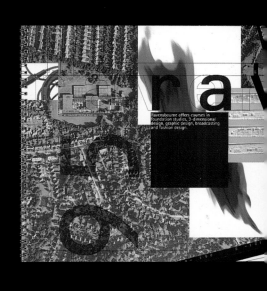

gra

Ravensbourne offers courses in foundation studies, 3-dimensional design, graphic design, broadcasting and fashion design.

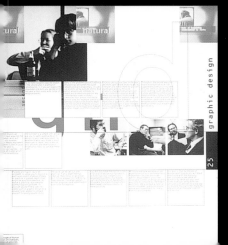

natural

graphic design

25

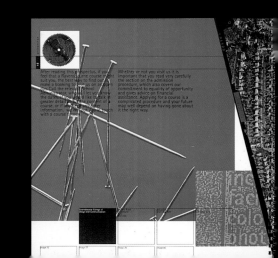

After reading this prospectus, if you feel that a Ravensbourne course might suit you, the best way to find out is to make a booking to visit us on an open day. Call the relevant School and let you know the date that you would like to talk in greater detail about... of a course, or if... information, we... with a course tutor...

Whether or not you visit us it is important that you read very carefully the section on the admission procedure, which also covers our commitment to equality of opportunity and gives advice on financial assistance. Applying for a course is a complicated procedure and your future may well depend on having gone about it the right way.

designer
Nick Bell

art director
Jeremy Hall

design company
Nick Bell

country of origin
UK

work description
Ultraviolet series of CDs,
with an advertising
poster, for Virgin Classics

dimensions
CDs
120 x 120 mm
4¾ x 4¾ in
poster
594 x 840 mm
23⅜ x 33⅛ in

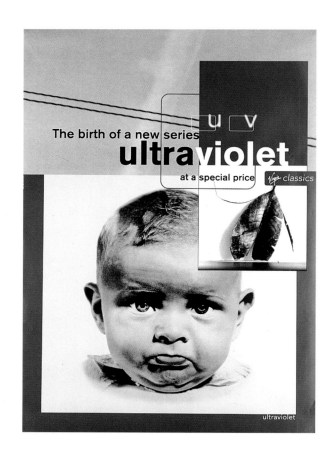

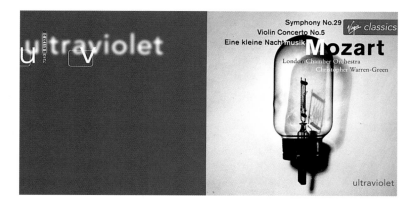

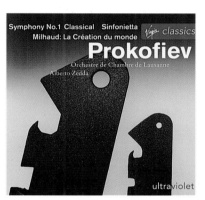

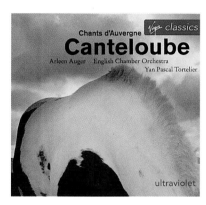

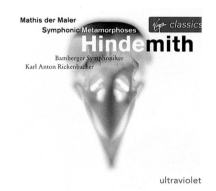

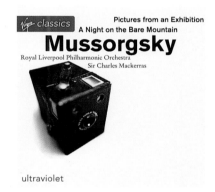

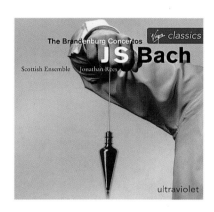

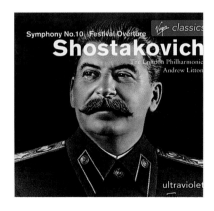

designers
Jason Edwards
Tim Hutchinson

college
Royal College of Art,
London

country of origin
UK

work description
Visual research project

dimensions
485 x 415 mm
19⅛ x 16¾ in

designer
Jeremy Francis Mende

photographer
Jeremy Francis Mende

college
Cranbrook Academy
of Art, Michigan

country of origin
USA

work description
Pages from a proposed
large format book,
*Archilochus: The Severity
of his Satire*, an allegory
exploring the mental
interstices between
developmental stages in
adulthood

dimensions
381 x 559 mm
15 x 22 in

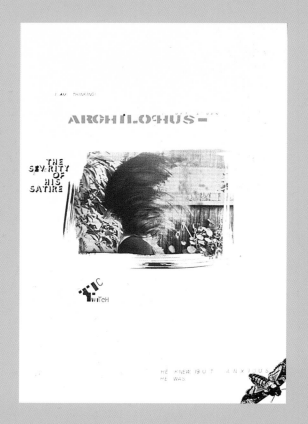

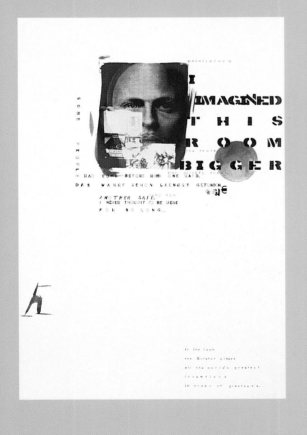

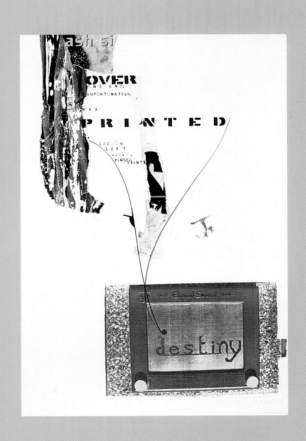

designer
Jennifer E. Moody

college
California Institute of
the Arts

country of origin
USA

work description
Furniture show poster

dimensions
711 x 1016 mm
28 x 40 in

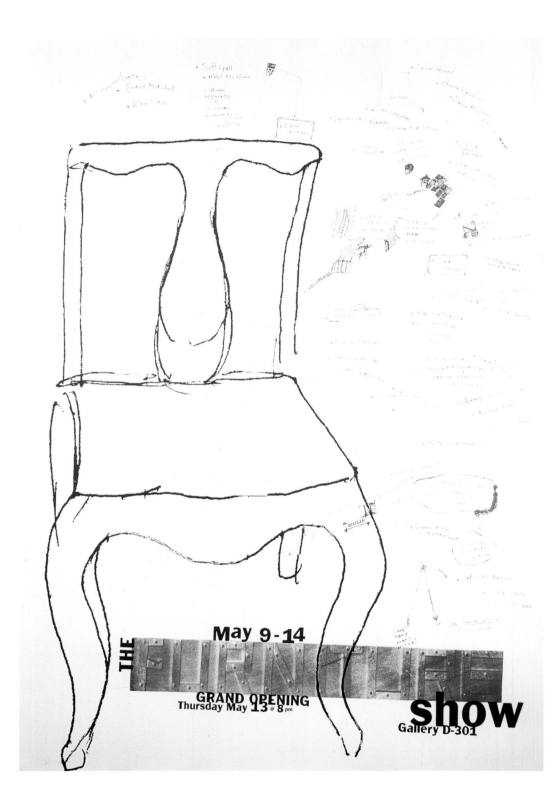

designer
Koeweiden/Postma
Associates

photographer
René Kramers

country of origin
The Netherlands

work description
Letterhead for René
Kramers Photography

dimensions
shown actual size
210 x 297 mm
8¼ x 11¾ in

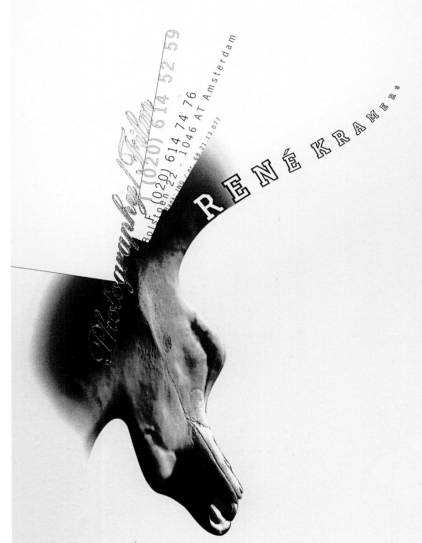

designer
Jeff Düngfelder

illustrator
Jeff Düngfelder

art director
Jeff Düngfelder

design company
Studio DNA

country of origin
USA

work description
Self-promotional poster

dimensions
241 x 419 mm
9½ x 16½ in

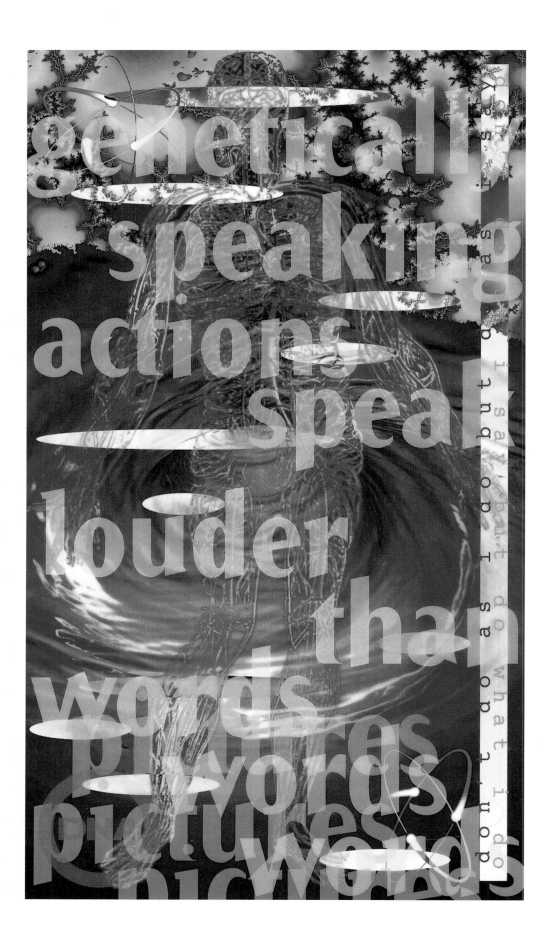

designer
Mark Diaper

photographer
Richard Foster

design company
Lippa Pearce Design
Limited

country of origin
UK

work description
Front cover and fold-out
poster from an AIDS
awareness booklet for the
Terrence Higgins Trust on
World AIDS Day

dimensions
booklet
120 x 120 mm
4³⁄₄ x 4³⁄₄ in
fold-out poster
347 x 466 mm
13⁵⁄₈ x 18³⁄₈ in

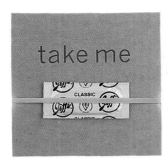

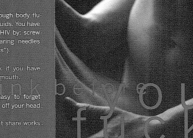

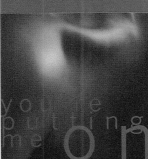

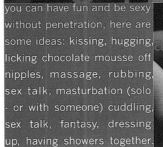

You can't catch AIDS, but you can catch HIV.
HIV is the virus that attacks your body's
immune system (which protects you from
diseases) leaving it vulnerable to serious
infections and cancers.

AIDS is a combination of serious infec-
tions and cancers that occurs when your
immune system is broken down by HIV.

There's no risk in sharing things like - cut-
lery, toilet seats, swimming pools, cups or
kissing. You can't become infected through
touching, hugging and shaking hands.

HIV can be transmitted through body flu-
ids - blood, semen, vaginal fluids. You have
a serious chance of getting HIV by: screw-
ing without a condom, sharing needles
and syringes ("works")

Blow jobs carry some risk if you have
cuts and sores in the mouth.

Drugs and alcohol - it's easy to forget
about safer sex when you're off your head.

Think before you shag. Don't share works.

sex: do it when you feel
ready it's okay to be differ-
ent do what you are com-
fortable doing if you don't
want to - you don't have to
no-one is worth the risk -
look after yourself what-
ever you do make it safe

The only way to make penetrative sex safer is to
use a condom.
Condoms protect you from sexually transmitted
diseases (stds) and pregnancy. They are less
messy. There is no wet patch. They are free.
They come in all shapes, sizes, flavours and
thicknesses. They protect you and your partner.
Check the date and the kitemark (tells you it's
been tested for safety and strength) on the con-
dom and read the instructions.
Practise makes perfect. You can get them free
from family planning clinics, genito-urinary clin-
ics (gum), brook advisory centres.
It's not who you do it with. It's what you
do that matters.

you can have fun and be sexy
without penetration, here are
some ideas: kissing, hugging,
licking chocolate mousse off
nipples, massage, rubbing,
sex talk, masturbation (solo
- or with someone) cuddling,
sex talk, fantasy, dressing
up, having showers together.

Help is at hand. If you're feeling anxious or have any questions
about HIV and AIDS, there are people you can call on who will
listen and advise you on any issue.

safer sex information issues around
being tested what condoms to use and
where to get them sexually transmitted
diseases if you feel you have been at risk

The Terrence Higgins Trust 0171 242 1010. For free and confi-
dential advice and information on HIV and AIDS and info about
where to go for testing. Open 7 days a week from 12 noon to 10pm.

National AIDS Helpline 0800 567123. Open 7 days a week, 24
hours a day for any information on HIV and AIDS and sexually
transmitted diseases. It's free and confidential.

Brook Advisory Centres 0171 708 1234. Offers face to face
advice on contraception to young people in 12 cities. Phone to
find out about the nearest one to you.

Family Planning Association 0171 636 7866 gives advice on
all sexual health matters including contraception and condoms.

designer
Richard Horsford

college
Ravensbourne College
of Design and
Communication,
Chislehurst

tutor
Gill Scott

120

country of origin
UK

work description
A campaign poster (right),
with information form on
the reverse (far right), to
raise awareness of the
issues facing deaf and
dumb people

dimensions
this page
420 x 594 mm
16½ x 23⅜ in
opposite page
594 x 420 mm
23⅜ x 16½ in

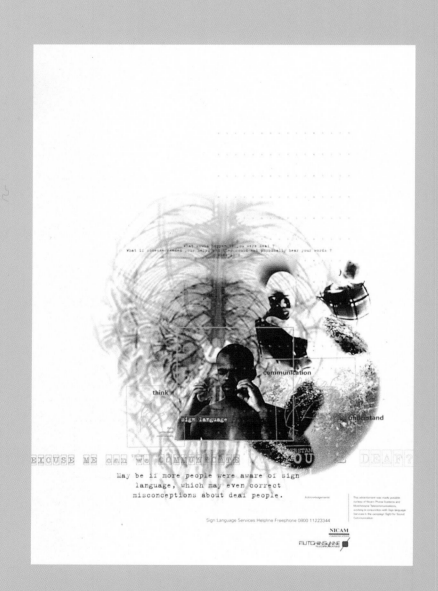

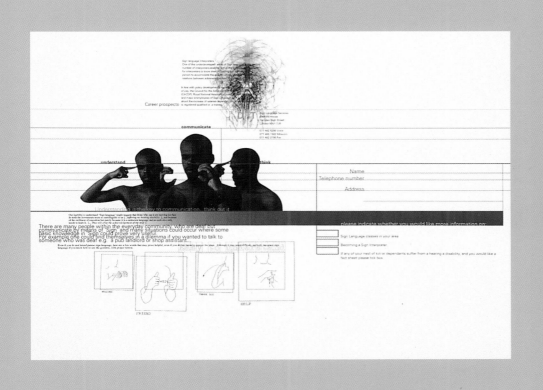

Career prospects

communicate

understand think

Name

Telephone number

Address

Understanding is the key to communication... think out it.

There are many people within the everyday community, who are deaf but communicate by means of 'Sign' and many situations could occur where some basic knowledge in 'Sign' could prove very useful.

For example one could find themselves in a dilemma if you wanted to talk to someone who was deaf e.g. a pub landlord or shop assistant...

please indicate whether you would like more information on:

Sign Language classes in your area

Becoming a Sign Interpreter

If any of your next of kin or dependents suffer from a hearing a disability, and you would like a fact sheet please tick box.

FRIEND HELP

designer
Conor Brady

photographer
Conor Brady

design company
React

country of origin
UK

work description
Front cover and spine of
the book *Dreams of a
Final Theory*, for Vintage
publishers

dimensions
145 x 198 mm
5¾ x 7¾ in

designer
Conor Brady

photographer
Tim Simmons

design company
React

country of origin
UK

work description
Front cover and spine
of the book *Small is
Beautiful*, for Vintage
publishers

dimensions
145 x 198 mm
5¾ x 7¾ in

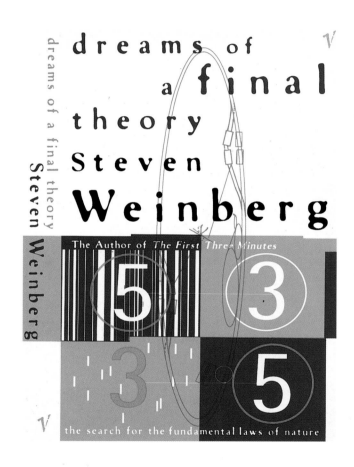

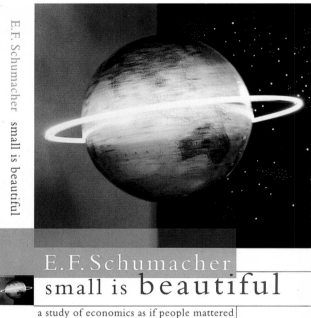

designer
Peter Dyer

photographer
Robert Clifford

design company
React

country of origin
UK

work description
Front cover of the book
The Acid House, for
Jonathan Cape publishers

dimensions
145 x 198 mm
5¾ x 7¾ in

designers
Peter Dyer
Conor Brady

photographer
Conor Brady

design company
React

country of origin
UK

work description
Front cover of the book
Europe: The Rough Guide,
for The Rough Guide
publishers

dimensions
145 x 198 mm
5¾ x 7¾ in

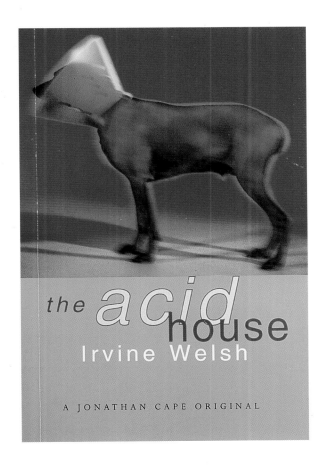

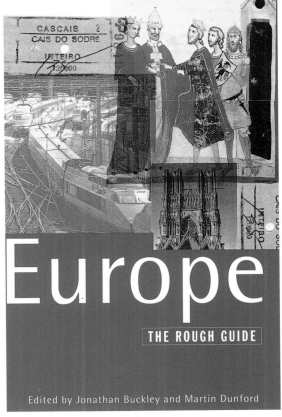

designer
Nick Bell

photographers
BBC Library
Nick Bell

art director
Roger Mann at
Casson Mann

design company
Nick Bell

country of origin
UK

work description
Design for manager's
office and department
reception at BBC Schools
Television: a typographic
skin to wrap around two
reception desks and to
cover the surface of a
freestanding storage wall

dimensions
each laminate sheet
1050 x 1250 mm
41³⁄₈ x 49¼ in

124

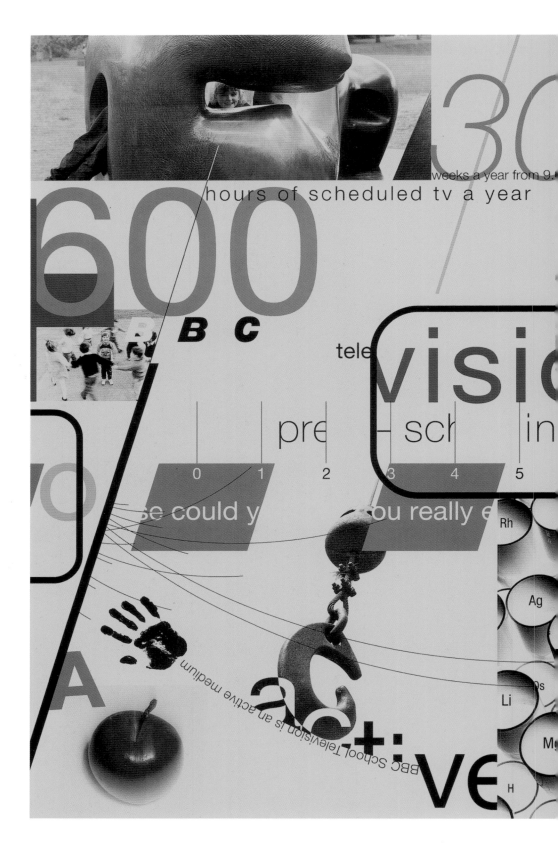

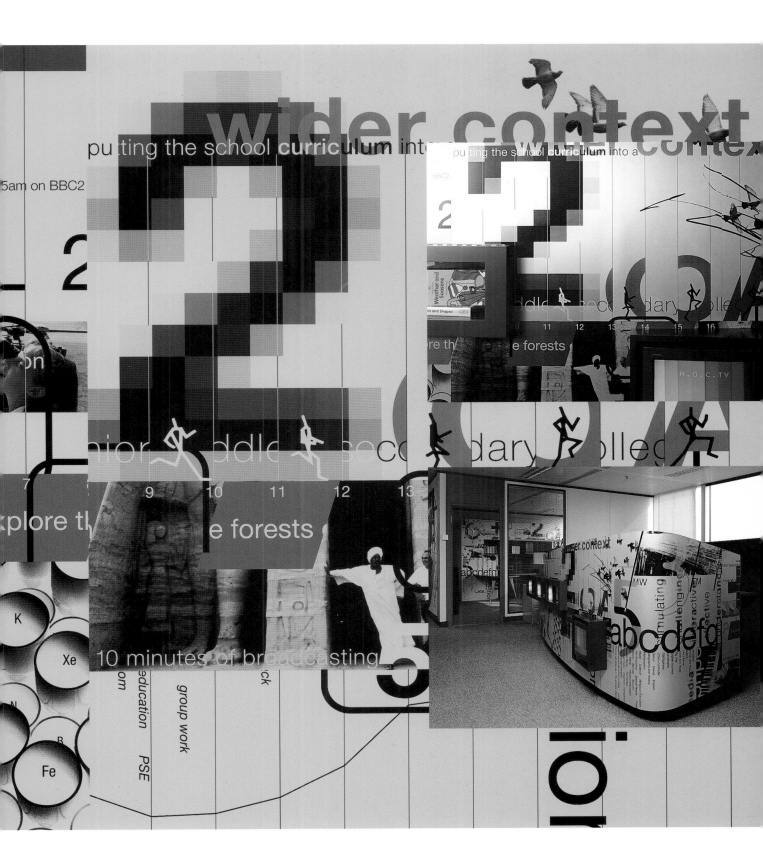

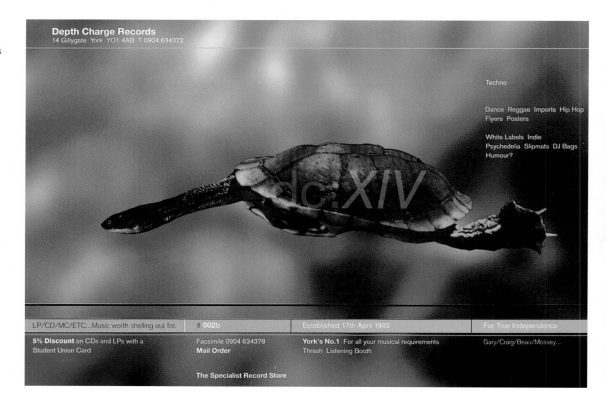

designers
Christopher Ashworth
Dave Smith

art director
Christopher Ashworth

design company
Invisible

country of origin
UK

work description
Four from a set of six
promotional postcards
for Depth Charge
Records

dimensions
shown actual size
149 x 100 mm
5⁷⁄₈ x 3⁷⁄₈ in

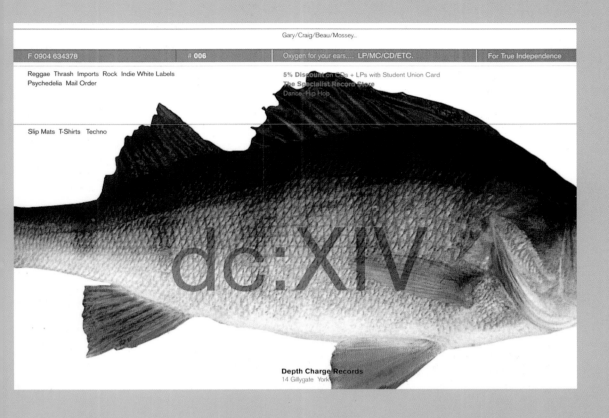

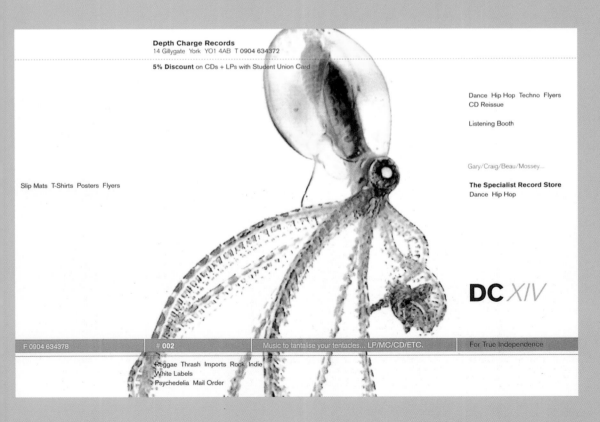

designer
Hans P. Brandt

design company
Total Design

country of origin
The Netherlands

work description
Hubble Space Telescope, a
poster for the European
Space Agency

dimensions
630 x 890 mm
24¾ x 35 in

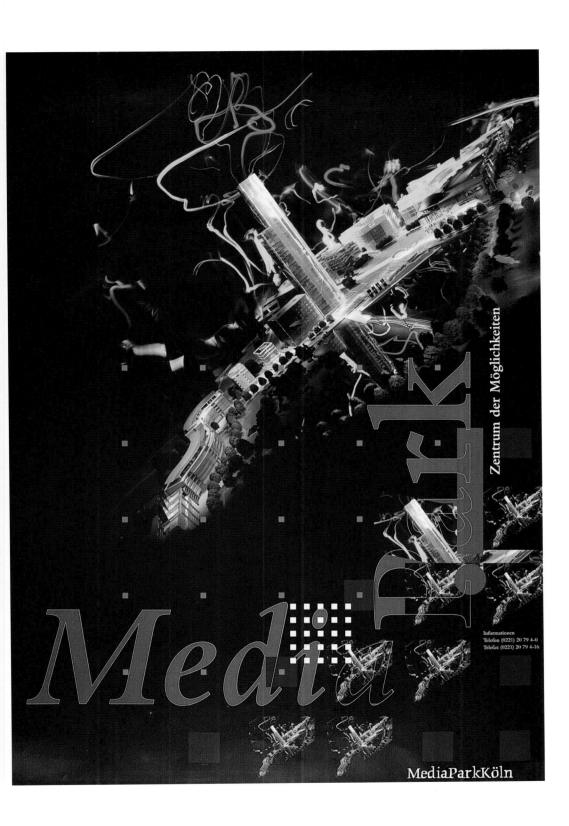

designer
Hans P. Brandt

photographer
Tom Mittemeijer

design company
Total Design

country of origin
The Netherlands

work description
MediaParkKöln, a poster

dimensions
597 x 850 mm
23½ x 33½ in

129

designers
Nilesh Mehta
Uday Patel

college
Ravensbourne College
of Design and
Communication,
Chislehurst

country of origin
UK

work description
Spread from a booklet
displaying the answers
given by people of various
ages and cultures to ten
questions posed by the
designers/publishers

dimensions
295 x 418 mm
11⅝ x 16½ in

130

Rose Guat Kheng Lim / John Attwood

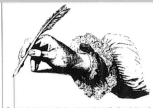

0.10 — If I had a million pounds, I would think of going on a luxury cruise around the wor...

Well, I think really I would put it into the foundation of a scholarship of some sort. I'd take ten percent for myself. But I've always wanted to fund a scholarship. If I was rich that's what I'd do.

0.9 — Favourite joke, it's a riddle. What is the difference between a lady and a diplomat? When a diplomat says yes he means perhaps, if he says no he's no diplomat. When a lady says no she means yes, if she says yes, she is no lady!

I've heard hundreds of jokes, but I can't really remember any at the moment.

0.8 — Drugs! My great grandmother in the twenties, I know, smoked Opium.

I had a puff of Hashish when I was in Egypt, when I was in the army. One or two had more than one puff, but I didn't really get any kick out of it. Then I had some friends who were artists many years ago, and I did sort of smoke some then as well, but I never got hooked.

0.7 — My husband.

Sir Michael Charlesworth. As I say, I never got married. I'm not a poof, but it just so happens he's a man, and a super fellow.

0.6 — Teach everybody.

Well, I suppose really the thing that causes more problems than anything is war. I used to be a soldier, and strangely enough, I'm a man of peace. I believe you have to have some sort of discipline, and when you have order and discipline people are happier.

0.5 — Yes, I'm a Christian.

Well, it is in a sense. I was brought up as a Christian, but now I find Christianity specifically, is not really pinned to my beliefs anymore. I'm sort of going towards an atheist. I think the sadness is when you've lost your religion, you lose your respect for God, but you also lose your respect for other people as well.

0.4 — Economic, I suppose.

I would say when people from overseas don't abide by our laws, if they behave as British people are suppose to behave, all British people aren't perfect—but if they break laws or break our conventions, that's what causes racism. For instance, the other day I was run over by a cyclist on the pavement and he wouldn't get off his bicycle. Now the fact that he was a black man wouldn't normally make me racist, but because every time you have a cyclist riding on the pavement it's a black man, it often causes racism when you have people who don't conform with the conventions. You know, British people aren't perfect, but there's so many things like that. For instance getting into a tube train, you wait until the people have got off, almost always you find that it might be someone from overseas, shall we say. I suppose some of them don't understand the conventions. This is really what causes racism. If the authorities favour them, which is what is happening in some working class areas, say Liverpool. I'm not what you would call working-class myself, although I worked damned hard, before I retired. There are extremely poor areas around the country. I think a lot of working-class people feel that especially West Indians have come to take their jobs, I think that is a cause of racism.

0.3 — Widowhood.

Certainly not death. I've never really had much pain, I've got arthritis. Oh, I don't know, I suppose being beaten up by a gang. A gang of seven people once tried to beat me up, but I used to be very strong and fit in those days, and I'm big of course, and these seven people once attacked me in the back streets of Manchester. I saw them off and two of them were in hospital and they didn't put me in hospital, but I wouldn't want to be beaten up by a gang. I can look after myself with one person but if I have three or four people that would be a fear.

0.2 — The day I got married.

Well I'm not married. I think it was when I qualified as an officer in the army.

0.1 — It used to be my collection of theatre programmes, but I didn't have enough room to house them all.

I've got you there, my Library.

Rose Guat Kheng Lim **John Attwood**

131

designer
Stephen Banham

art director
Stephen Banham

design company
The Letterbox

country of origin
Australia

work description
Front cover and spreads
from the magazine
Qwerty, issue 5

dimensions
80 x 105 mm
3⅛ x 4⅛ in

132

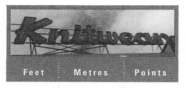

Feet	Metres	Points
25	8	2275

All I was given was a street-map reference
and the promise of something very exciting
indeed. Always inclined to take up such an
offer, I followed the instructions which led
me into the deep industrial heartland of
Richmond. I stood on the spot marked X on
the map and wondered what it was about.
I slowly looked up and there it was. The
biggest upper case K I had ever laid my
eyes on. This type, despite its scale, was
obscured from distant view by the buildings
that had since been built around it.

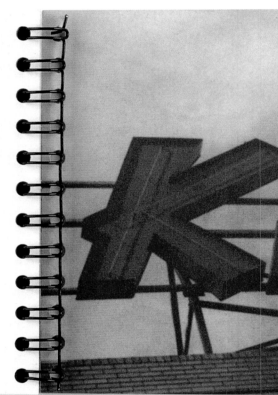

Feet	Metres	Points
10	3-5	995

Like a bright glowing red signature atop the mock castle architecture of the building's facade, the Astoria taxi sign would have to be the best loved lower case a in Melbourne (for those of us who concern ourselves with such things). Its spontaneous scribble-like form somehow runs contrary to its physical size and complexity of construction.

Feet	Metres	Points
10	3	900

This typographic drag queen is possibly the most recognisable in Melbourne. Its scale and sense of occasion beckons the viewer inward asking you to politely ignore its crumbling facade.

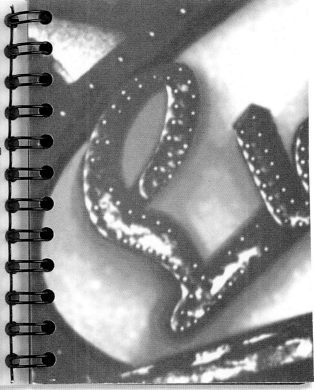

133

Feet	Metres	Points
40	13	3698

Situated in Sydney's King Cross, the largest C is predictably that of a Coca Cola Sign. One of the most famous over-sized members of our alphabet, this sign is seen by approximately 28 million people each year.

For those interested in the structural details, it contains 1,785 kilometres of neon tube, and 5 kilometres of electrical cable. It is the largest backlit display in Australia.

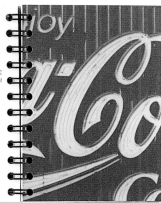

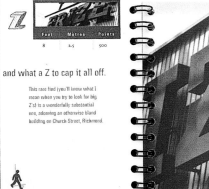

Feet	Metres	Points
8	2-5	500

and what a Z to cap it all off.

This rare find (you'll know what I mean when you try to look for big Z's) is a wonderfully substantial one, adorning an otherwise bland building on Church Street, Richmond.

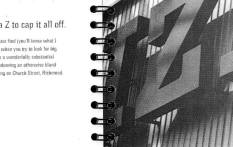

designer
Alan Chandler

country of origin
UK

work description
Spreads from
typographic
sketch books

dimensions
300 x 420 mm
11⅞ x 16½ in

136

Steven D. Lavine became CalArts' third president in July of 1988. Before coming to CalArts, he was associate director for Arts and Humanities at the Rockefeller Foundation in New York City. There he provided leadership in the full spectrum of visual, performing and literary arts, with special emphasis on programs that challenge contemporary artists and cultural institutions to work toward an international and intercultural focus. While at the Rockefeller Foundation, he served on the board of directors of the Kitchen Center for Video.

Music, Dance, Performance, and Film and of the Mabou Mines Theater Collective. He was also a selection panelist for the INPUT Public Television Screening Conferences in Montreal, Canada and Granada, Spain.

He currently serves on the board of directors of the Los Angeles Philharmonic, the American Council for the Arts, and KCRW-FM National Public Radio, as well as the Governing Committee of the Institute for Advanced Study and Research in African Humanities at Northwestern University (for Northwestern and the Social Science Research Council), the Visiting Committee of the J. Paul Getty Museum, and the National Advisory Committee of the Smithsonian Institute's Experimental Gallery. He has served on the board of directors of the Operating Company of the Music Center

of Los Angeles, as co-director of the Arts and Government Program for the American Assembly at Columbia University, and co-chair of the Mayor's Working Group of the Los Angeles Theatre Centre. In 1991 he co-edited with Ivan Karp, *Exhibiting Cultures: The Poetics and Politics of Museum Display.* In 1992 the Smithsonian Institution Press released their second co-edited volume, *Museums and Communities: The Politics of Public Culture.*

of providing

their potential to its ful

your chosen art w

Schools of Art, Dance, Film/Video, M

caLArts affords you, the stud

where appropriate, to engage in your own interdiscipli

you will work closely with a distinguished fa

give you access to dedicated and experienced faculty through tuto

scheduled classes. We

While teaching the mastery of tech

working with

brought to campus by a variety of ongoing visiting

prepared to recognize the com

STEVEN D. LAVINE, PRESIDENT

president's message

Throughout its history, calarts has been guided by its founding goal
ironment which enables emerging artists to develop
nt. At calarts you can perfect skills in
ing knowledge of the other arts through our
atre, and the Division of Critical Studies.
opportunity to forge new relationships among the arts, and,
orations. ● At calarts,
acticing artists. Innovative programs
oring, and independent studies as well as through regularly
creativity and self-discipline.
ive to respond to your individual needs. ● In addition to
r faculty, you will have the opportunity to learn from many other distinguished artists
ns. ● As future artists, you must be
cal, social, and aesthetic questions and respond to them

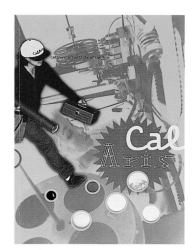

th informed, independent judgment. At calarts, these abilities are fostered in the Division of Critical Studies as well as in the arts
hools. The Critical Studies faculty of dedicated teachers and scholars will introduce you to the basic methods and disciplines of the liberal
ts—the humanities, sciences, and social sciences—and especially to concerns of the arts and thought processes in the arts. This program
ll broaden your knowledge and understanding of the world and help you to analyze issues critically and imaginatively. ● During your
udies at calarts, you will explore the philosophical, literary, social, and aesthetic dimensions of a diverse culture. You will meet and
ork with faculty, students, and visiting artists who represent various ethnic, cultural and national groups. Through our Community
ts Partnership (CAP), you will have the opportunity to work at cultural centers in neighborhoods throughout Los Angeles. ● As we
nsider calarts' future, we see four immediate opportunities for enhancing the education we offer. The first is to continue to work
ward including a broad range of voices—ethnic, cultural, and international—in every area of the Institute. The past decade has
ought rapid change in this arena, but there is still a long road to travel, in the arts as in our society. The second is to make available
e array of resources for interactive and multimedia artmaking. Integrated media technologies will create a firm platform for
terdisciplinary exploration, the third area in which we hope to see development in the rest of this decade. calarts was designed
t only to offer the arts individually but to encourage interdisciplinary inquiry. As we enter our second quarter century, we are still
allenged to fulfill this vision of our founders. Fourth, but not at all least among these priorities, is to strengthen the place of
riting at calarts. Recently, we've put in place an MFA program in Critical Writing/Arts Practice. Now we must work toward a full-
ale writing program that takes advantage of the unique interdisciplinary resources at the Institute. ● During the two and one-
alf decades of its existence, calarts has been, appropriately, in a continual state of evolution. These new initiatives recognize
at the place of the arts in society is in constant flux, and so necessarily calarts must change and
evelop. At calarts our mandate is to help create the future; we invite you to join us in this adventure. *Steven D Lavine*

designer
Stephen Hyland

college
The Surrey Institute of
Art & Design, Farnham

tutor
Mike Ryan

country of origin
UK

work description
Spread from *Area 39*,
a magazine project
covering experimental
music, design, and
multimedia

dimensions
210 x 297 mm
8¼ x 11¾ in

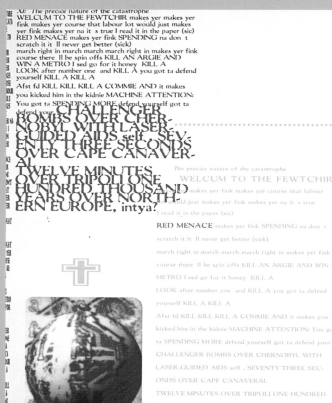

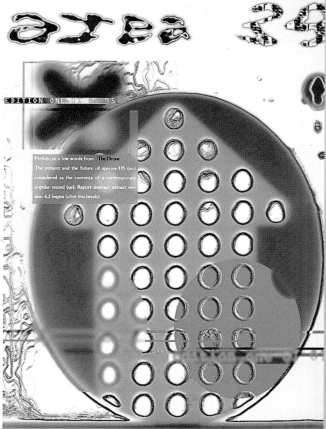

designer
Ed Telling

college
The Surrey Institute of
Art & Design, Farnham

tutor
Mike Ryan

country of origin
UK

work description
Spread from *Area 39*,
a magazine project
covering experimental
music, design, and
multimedia

dimensions
210 x 297 mm
8¼ x 11¾ in

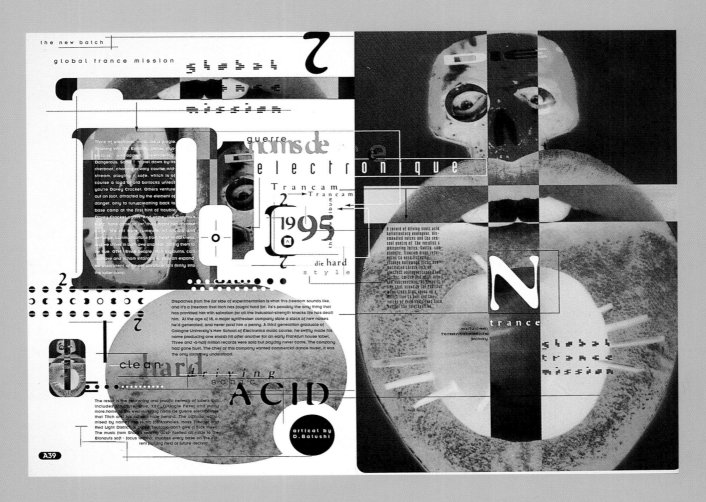

designer
Naomi Mizusaki

art directors
Rosie Pisani
Pete Aguannd
Drew Hodges

design company
Spot Design

country of origin
USA

work description
Advertisements for the
Independent Film Channel

dimensions
200 x 152 mm
7⅞ x 6 in

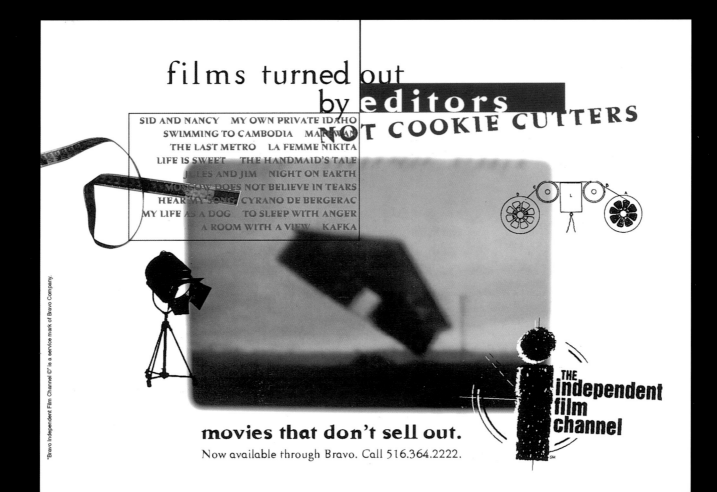

designer
Vincent Sainato

photographer
Mark Hill

art director
Drew Hodges

design company
Spot Design

country of origin
USA

142

work description
Page from the 1994
Hanna-Barbera
*Flintstones Collectibles
Calendar*

dimensions
280 x 660 mm
11 x 26 in

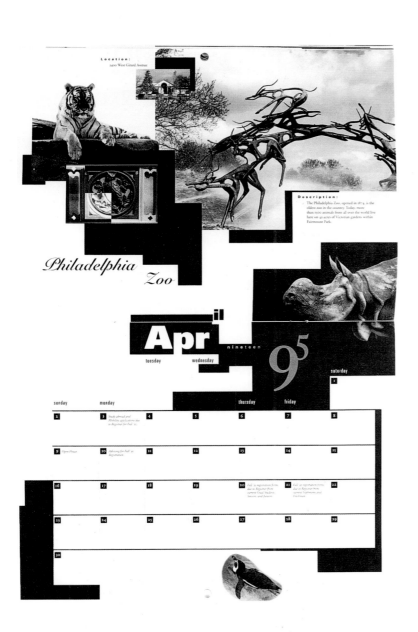

designer
George Plesko

photographer
George Plesko
Tom Davies

art director
Nancy Mayer

design company
Mayer & Myers

country of origin
USA

work description
Page from *The University of the Arts Calendar and Student Handbook*, for The University of the Arts, Philadelphia

dimensions
277 x 425 mm
10⅞ x 16¾ in

143

designer
Richard Shanks

college
California Institute
of the Arts

country of origin
USA

work description
Pages from *Shoes Make
The Man*, a false diary
that is a self-authored
experimental typography
project exploring cultural
identity and stereotype

dimensions
254 x 381 mm
10 x 15 in

144

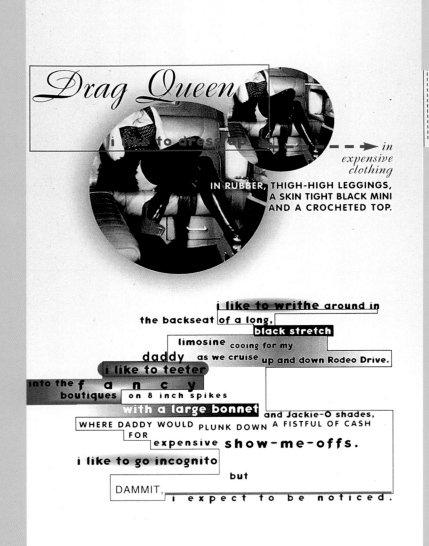

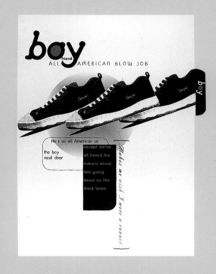

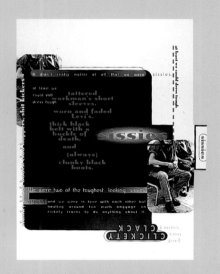

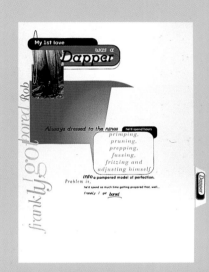

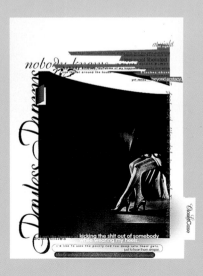

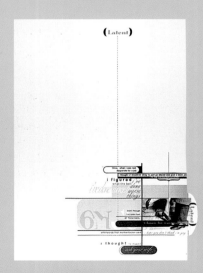

designer
Russell Warren-Fisher

design company
Warren-Fisher

country of origin
UK

work description
Spread and cover from a
brochure for Camilla
Arthur, shown with the
promotional envelope

dimensions
brochure
320 x 255 mm
12⅝ x 10 in
envelope
380 x 300 mm
15 x 11⅞ in

146

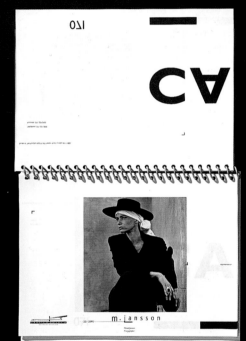
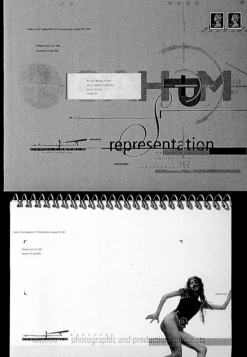

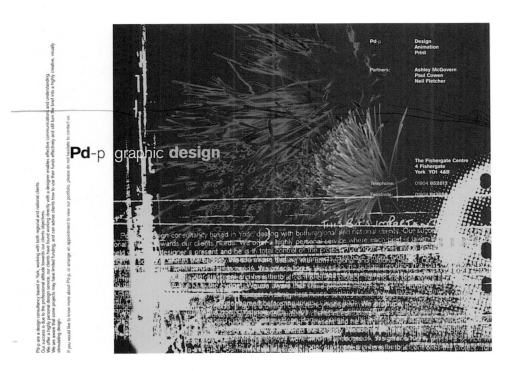

designer
Neil Fletcher

design company
Pd-p

country of origin
UK

work description
Self-promotional
postcards

dimensions
210 x 148 mm
8¼ x 5⅞ in

147

designer
Cathy Rediehs Schaefer

art director
Tom Geismar

design company
Chermayeff & Geismar
Inc.

country of origin
USA

148

work description
Front cover and spreads
from a brochure
launching a reorganized
office furniture company,
the Knoll Group

dimensions
279 x 279 mm
11 x 11 in

Planning and furnishing the workplace today means thinking far beyond metal, wood and plastic. The people who work are changing, and so are the tools that they use. Demographic trends, leaps in computer and communications technology, reconfigured organizational structures, new sensitivity to workers' well-being and the environment —all make the workplace a focal point for unfamiliar and complex concerns. At **Knoll,** a company uniquely founded on the concept of **design,** we are redefining form and function to accommodate these new dimensions.

The intelligent workspace **adapts to companies and their people.**

intelligent workspace **supports the**

process.

The intelligent workspace is the result of more than fifty years of excellence in office design, and over a century of technological leadership.

Since 1938, Knoll has followed its vision of applying the finest design to work environments. Inspired by the creative genius of the Bauhaus school in Germany, Hans Knoll founded his company on the idea that good design could benefit everyone. Florence Knoll, his wife and partner, pioneered the modern office by integrating every aspect of its space, furnishings and equipment.

Westinghouse, parent company of The Knoll Group, has been at the technological forefront ever since 1886, when its system of alternating current launched the age of electricity. From energy to microelectronics to furniture, the Westinghouse name guarantees world-class

Knoll embodies a heritage of design and technology.

technology and the highest standards of total quality.

These unmatched traditions of advanced design and high technology, along with customer-focused service and global distribution and manufacturing, stand behind the Knoll commitment to create workspaces where people can do their best work and enjoy doing it.

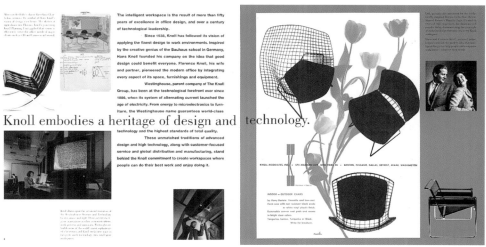

149

type
type
type
type
type
type
type
type
type
type
type
type
type

type as text

designer
Kees van Drongelen
(with cooperation from
Christine Baart and Harco
van den Hurk)

design company
Post & Van Drongelen,
VisualSpace

country of origin
The Netherlands

work description
Title page and spreads
from the book *The
Invisible in Architecture*,
for Academy Editions

dimensions
250 x 305 mm
9⅞ x 12 in

Questions, comments, interviews and criticisms by Ole Bouman and Roemer van Toorn (additional research: Dave Wendt)

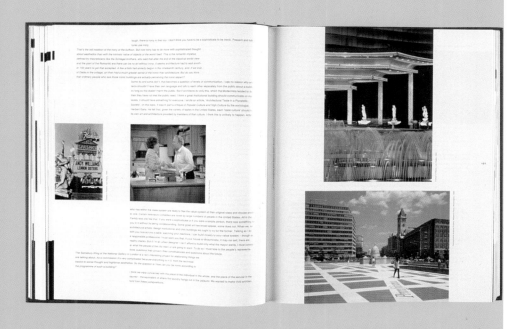

designers
Rudy VanderLans
Gail Swanlund

art director
Rudy VanderLans

design company
Emigre Graphics

country of origin
USA

work description
Spreads from *Emigre*
magazine, issue 32

dimensions
282 x 425 mm
11⅛ x 16¾ in

154

Breathing Through the Body of A Typography of A

How earth uncovered the body,
 the suffocating body of A.
How no more unjust treatment shall pervade,
 the power of A: unseen, unknown.
The body of A, alive.
How the inside shall work its way out into breathing,
 only breathing in thoughts in this future.
If this is my lung, then this is my breathing alphabet,
 my lung pulled out alive.
Tack me onto the letter alive.
Make the breathing.
Make no more words be known, but breathing, but A.
All other infantile extremities sloughed off as human waste.
Let out the C in a wild yet peaceful cough.
Fart out all F's, ultimately.
Squeeze out all the hate of H as monstrous waste piles.
Shoot any last ounce of jizm to the death of J itself
The very nemesis core ejected in the oblivion nowhere of N.
Quit out of any Q left behind quirky.
Every last drop of urine forcibly applied to the uselessness of U.
All vile entities exorcised in the form of V-pus.
The very notion of waste scraped out with wisdom
 leaving no W behind.
Expel, without doubt, any mark of X.
Spill the boring yawn of Y.
Kill Z frankly in the infectious ferment of zero.
All other body parts singing to A,
 the lung song lifting up in marvelous puffs of breath.
All control given over to almighty lung life.
The continued extermination of the floral chart.
Other frivolous letter forms, shall be attended to,
 as necessary, by the lung proper.
Certain waste, such as shit,
 always tempting the lung as life.
The leukocytes guarding lung posts.
Shovel in hand, the dumping,
 keeps the alphabet moving, keeps the breath alive in gusts.
Sail the wordsmith smooth and horizontal.
Sail next door's lung life.
If any sound, be it the breath of A,
 be it the breath of A in all extremes.
So Cave. So Greek. So Roman. So Gothic. So Adobe.
So in the end, so A.
The sound of letters only there in A, the sound of breathing.
The breathing alphabet as continuous as life itself.
Live the alphabet in columns of A.
Inscribe the A here and live, breathing.
So complete in this life,
 the breathing A.
 · · ·

"Pack my box with A's breathing,"
 says Goudy.
Pack the sexy box with the bodies of B, P, and R.
Pack them divine.
Two ton breathing template applied.
Live the lust of letters breathing down your neck.
Lettered body parts indicating breath ports.
No more limits to mouth opening.
My fists open.
Fists closed in waste products.
Stinky fist gone down.
Lovely fist open in the breathing port.
Enter the breathing port alive,
 let life.
Live in the A life breathing.
Sex up the breath port with plenty of B.
Bigger P song singled out in the life long.
Goudy's eminence cut as early as Rome 114 A.D.
The breathing beginning as early.
The A lifting up only now in verse,
 in a long poem breathing the life of A.
Live a life in the box open.
 · · ·

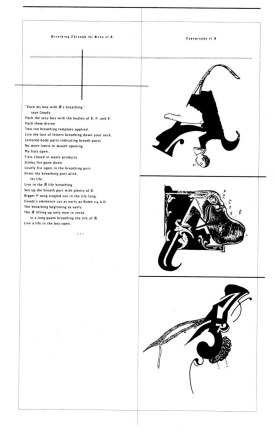

26 27

alternative? Now that it can no longer rely on one of the big stories that are dead and buried according to Bell and Lyotard? Many replaces the big narratives by micro-narratives or, as we saw, by the "critical" ideologies adopted by the great majority, which retain at least the prospect of a better world. How is the self-centered ethic of the designer yearning for the status of an artist to be avoided?

Two concepts seem to me important as the foundations for a proper design ethic. The first is respect for the other. By that I mean something quite different from taking account of the average preferences of a target group as determined by marketing techniques based on consumer panels, etc. In this respect, what I have in mind is not the other insofar as s/he can be equated with still others who are part of the same target group of a marketing strategy that basically reduces everyone to a consumer. What I envisage is the other insofar as his or her values and images differ from mine. Few designs show this openness towards the other – or question the implicitly assumed hegemony of their own cultures. The second concept is the d e s i r e of the designer him or herself, for which a design ethic should leave ample scope. S/he could be present in the design as the s u b j e c t of desire, not as the manipulator of the demands, needs and wishes of others. So does this mark a return to the romantic image of the designer as autonomous subject, in order to escape from the false romanticising and sentimentality of commercial communication? No. Desire is a source of poetic production. It aims for the Utopian element, the dream character of reality in the strongest sense of the word. Desire transcends the world of available objects and does not cover up the fundamental shortcoming of the human condition with the endless repetition of satisfying needs.

D e s i r e accepts the shortcoming as an insoluble characteristic of human existence and is diametrically opposed to promises that (consumer) needs will be met. Desire for the not-present object keeps the line to the future open. It can only be put into words by a rich voice.

We can now see that a desire formed the basis of both the Traditionalist and the Modernist ethic, although this was not recognized as such by the spokesmen for each movement. It is the desire for a rational society in which strength of argument will triumph over power and violence, the desire for a society in which justice will be done to everyone, not just to an élite.

Can design be more than it now is: streamlining of communication controlled by the system of power and money? The affirmative answer to this question is based on two observations.

First, this system is not monolithic; fractures and contradictions can be seen. It is not uncommon for these to be intensified by the still operative ideals and sense of responsibility of policy makers. Designers can cooperate productively with them, although often only on a temporary basis.

Second, the system constantly sets its own limits. At the edge of its territory, an extraterritoriality arises in which the interests and wishes of marginalised groups and individuals ask to be articulated. Since the sixties, a rival public domain has existed that has bombarded the system from the flanks with unwelcome counter-information and counter-images.

Strategies aimed at the general good and social/cultural/political priorities form the points of action to a kind of design that positions itself beyond the *status quo* and wants to be more than the *bosso continuo* of power and the market. Design like this breathes fresh air into the polluted and blocked lungs of the body of society. It is inspired as much by the rejection of injustice as by the desire for the sublime. This field is a public domain that must itself be constantly r e d e s i g n e d.

The C a b

I owe this typology, to a discussion with an outsider, architect and professor of architectural design at the technological university of eindhoven, on differences and similarities between students and practitioners of the design disciplines architecture and graphic design.

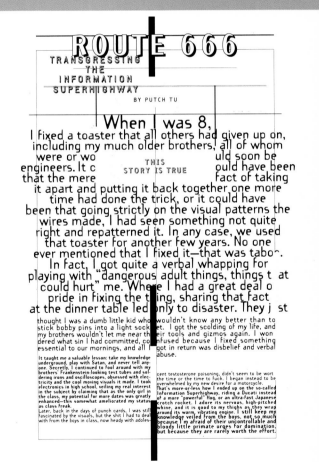

ROUTE 666
TRANSGRESSING
THE
INFORMATION
SUPERHIGHWAY
BY PUTCH TU

When I was 8,

I fixed a toaster that all others had given up on, including my much older brothers, all of whom were or wo uld soon be engineers. It c **THIS STORY IS TRUE** ould have been that the mere fact of taking it apart and putting it back together one more time had done the trick, or it could have been that going strictly on the visual patterns the wires made, I had seen something not quite right and repatterned it. In any case, we used that toaster for another few years. No one ever mentioned that I fixed it—that was taboo.

In fact, I got quite a verbal whapping for playing with "dangerous adult things, things t at could hurt" me. Where I had a great deal o pride in fixing the t ing, sharing that fact at the dinner table led only to disaster. They j st thought I was a dumb little kid who wouldn't know any better than to stick bobby pins into a light sock et. I got the scolding of my life, and my brothers wouldn't let me near th eir tools and gizmos again. I wondered what sin I had committed, confused because I fixed something essential to our mornings, and all I got in return was disbelief and verbal abuse.

It taught me a valuable lesson: take my knowledge underground, play with Satan, and never tell anyone. Secretly, I continued to fool around with my brothers' Frankenstein-looking test tubes and soldering irons and oscilloscopes, obsessed with electricity and the cool moving visuals it made. I took electronics in high school, veiling my real interest in the subject by claiming that as the only girl in the class, my potential for more dates was greatly enhanced—this somewhat ameliorated my status as class freak.

Later, back in the days of punch cards, I was still fascinated by the visuals, but the shit I had to deal with from the boys in class, now heady with adoles-

cent testosterone poisoning, didn't seem to be worth the time or the time to fuck. I began instead to be overwhelmed by my new desire for a motorcycle. That's more-or-less how I ended up on the so-called Information Superhighway, riding a Ducati instead of a more "powerful" Hog, or an ultra-fast Japanese crotch rocket. I adore its nervous, high-pitched whine, and it is good to my thighs as they wrap around its warm, vibrating engine. I still keep my knowledge veiled from the boys, not so much because I'm afraid of their uncontrollable and bloody little primate urges for domination, but because they are rarely worth the effort.

155

designers
Stephen Shackleford
Jan C. Almquist

photographer
James B. Abbott

art director
Jan C. Almquist

design company
Allemann Almquist
& Jones

country of origin
USA

work description
Front covers and spreads
from a two-part 1993
Annual Report for The
Franklin Institute Science
Museum

dimensions
210 x 290 mm
8¼ x 11⅜ in

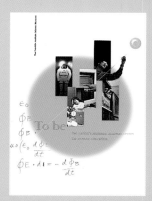

In 1934, The Franklin Institute opened a museum with the new idea of "learning by doing," using interactive exhibits. When the Mandell Futures Center and Tuttleman Omniverse Theater opened in 1990, the Museum took another step forward, presenting the science and technology of the 21st century—technology that is currently shaping our lives—in informative, engaging, and entertaining ways.

Almost 1,000,000 people visit the Institute each year. Using interactive videodisks, computer games, demonstrations and interactive displays, science is a lively art at The Franklin Institute.

The Strategic Plan calls for another new look at how the Museum is organized and for the redesign and renovation of almost every Institute exhibit. Exhibits in the Science Center

Museum Visitors

Museum Visitors	
Groups	155,748
Individuals	834,127
Campsin Overnight Program	15,000
Facility Rentals	30,000
Workshops	2,000
Total	**1,036,875**

will be expanded and organized around broad themes of basic science—life science; earth and the environment; transportation; and space and astronomy. An expanded traveling exhibition gallery will enable the Institute to accommodate larger special exhibits.

The Mandell Futures Center will focus on two areas of rapidly changing technology—biotechnology and information technology. The information technology exhibit, "Inside Information," is scheduled to open to coincide with the 50th anniversary of the ENIAC computer in 1996.

A renewed focus on evaluation will provide guidance in developing these new initiatives. Key criteria for future growth are enhanced staff training, expanded family programming, and a commitment to continuous quality improvement and to serving a diverse public.

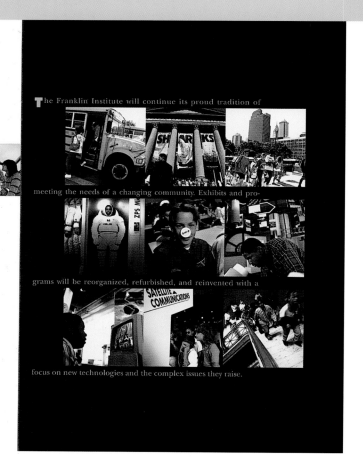

The Franklin Institute will continue its proud tradition of meeting the needs of a changing community. Exhibits and programs will be reorganized, refurbished, and reinvented with a focus on new technologies and the complex issues they raise.

Programs for recognizing scientific excellence are critical in building excitement and interest in science and take place on many levels. For students, the Institute coordinates the region's largest science fair and works to help girls achieve science merit badges. Scientists and inventors have been recognized through Franklin Institute award programs since 1825. Through the Bower Award and Prize for Achievement in Science, founded in 1988, the Institute conducts an international search to identify a distinguished scientist to receive one of the largest American cash prizes in science.

In 1994, The Journal of The Franklin Institute will be reissued as The Journal of The Franklin Institute: Engineering and Applied Mathematics. A second journal, Technology: The Journal of The Franklin Institute, will also be launched in 1994.

Scientists

Bower Awards	300 reviewers	200 participants
Scholarly Journals	500 subscribers	
Symposia, lectures	3,000 attendees	
Science and Arts Committee	50 members	

4,050

These activities fulfill an important and unique aspect of the Institute's mission, providing opportunities for students, visitors, and educators to interact with scientists whose contributions are shaping our world and our future.

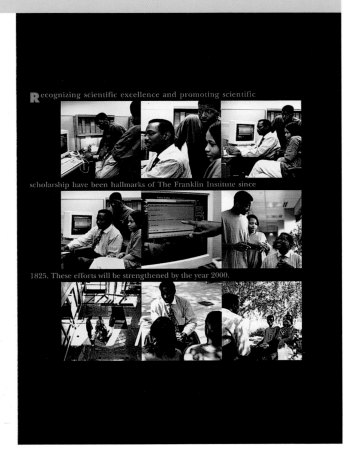

Recognizing scientific excellence and promoting scientific scholarship have been hallmarks of The Franklin Institute since 1825. These efforts will be strengthened by the year 2000.

157

designer
Kees Nieuwenhuijzen

country of origin
The Netherlands

work description
Front cover, title page,
and spread from *The
Low Countries*, for the
Flemish-Netherlands
Foundation "Stichting
Ons Erfdeel"

dimensions
175 x 234 mm
6⁷⁄₈ x 9¹⁄₄ in

158

THE LOW COUNTRIES

ARTS AND SOCIETY IN FLANDERS
AND THE NETHERLANDS
A YEARBOOK

1994·95

Published by the

Flemish-Netherlands Foundation 'Stichting Ons Erfdeel'

OMA, *Kunsthal*, Rotterdam
(Photo by Michiel Hofman).

attention to one aspect that is often neglected or undervalued: Koolhaas' unconventional use of materials. He uses steel sections next to debarked tree trunks, yellow travertine next to roughly worked concrete. All materials are of equal value to the artist, wrote Adolf Loos in 1898, adding that the cladding was more important than the construction which held it in place, and that textiles are the common origin of both architecture and clothing. A particularly clear illustration of this thesis is the Kunsthal's auditorium, which is separated from the surrounding space by a thick curtain. When the auditorium is not in use, the curtain is kept open; when it is rolled up the rising hem gives it the elegance of an evening gown. The architect noted for his conceptual rigour has here produced an especially tactile building. Outside, the walls and roofs are covered with semi-transparent corrugated sheets. They reveal what usually remains unseen: the skeleton of the wall, the movement of the lift – but they conceal the windows. In the evening when artificial light projects the windows onto the corrugated sheets, the effect is unearthly.

PAUL VERMEULEN
Translated by John Rudge.

The designs marked with an asterisk have are been built.

An exhibition of the work of OMA will be held at the Museum of Modern Art in New York at the end of 1994. On this occasion the book *Small, Medium, Large, Extra Large* (a survey of the history of OMA) will be presented.

FURTHER READING Rem Koolhaas – *Office for Metropolitan Architecture.* In: *Architecture and Urbanism*, 217, October 1988.

DIJK, HANS VAN, *Rem Koolhaas: Architect* (text in Dutch and English). Rotterdam, 1992.

From

Gazettiers to Newspaper Groups

The Press in Flanders

At the time of Belgium's independence in 1830, public life in Flanders was completely gallicised. The Flemish middle classes, those who could afford a daily newspaper, read mainly French publications. Flemish newspapers had a very small share of the market, and in any case appeared only one to three times a week. This weak position contrasts sharply with the flourishing beginnings of the Flemish press in the seventeenth century. In the Spanish Netherlands most publications were in Dutch, and the Flemish press set the standard for Europe.

The Flemish press before Belgian Independence

The development of the first Flemish newspapers during the rule of Albert and Isabella (1598-1631) had much to do with the fact that Flanders had many printers of renown. The first *gazettiers* were, after all, also printers. The first *gazettier* in the Southern Netherlands to be granted a licence to publish a newspaper was Abraham Verhoeven, with *Weekelycke Tydinghe* (Weekly News, 1629-1631). Two other Antwerp *gazettiers* were also given permission to publish newspapers. Other licences were granted to Flemish *gazettiers* in Ghent, Bruges and Brussels. At that time Dutch was a lively cultural language which was spoken in the highest circles. Naturally, there was no freedom of the press under the Ancien Regime. The press was subject to censorship and was the servant of those in power at the time.

The lead which the Flemish press had built up under Spanish rule (1555-1713) was lost during the Austrian period (1713-1792). Many 'enlightened' journalists of liberal ideas fled from France and came to Flanders, where they were able to resume their activities under the 'enlightened' Austrian rulers. The ideas of the French Enlightenment had enormous impact, and French became the language of culture. More and more French-language newspapers were launched in Brussels. During the period of French rule (1792-1814) French became the language of society and the upper classes abandoned Flemish for French. French-language newspapers increasingly drove out those in Flemish. During the Napoleonic period, a sort of linguis-

GAZET VAN ANTWERPEN

Since 1987 we have designed and
managed virtually every aspect of ADT's
visual communications strategy, including
its last six annual reports.

ADT is the largest electronic security and
vehicle auction services company in the
world. Its annual report is aimed primarily
at its shareholders in Europe and North

America, and its customers in thes
regions. The emphasis shifted in 19
when ADT changed its listing from
London to New York. Since then w
have identified the language to whi
the audience there respond.

Providing peace of mind to
customers in the home and the
workplace

designers
Simon Browning
Mason Wells

photographer
Tomoko Yoneda

art directors
Ian Cartlidge
Adam Levene

design company
Cartlidge Levene Limited

country of origin
UK

160

work description
Spread from a brochure
for Cartlidge Levene
Limited

dimensions
295 x 420 mm
11⅝ x 16½ in

993 annual report we worked
client's team to define the
bjective: to portray ADT as a
-oriented organisation leading
e auctions and security services
Our design emphasises ADT's
n to customer service by
g its close relationships with
om major banks to homeowners.

We managed every aspect of the report
including art directing the photography
across the US, having proofs read in
Florida via satellite link and overseeing the
production run of 90,000. For the interim
report we split the printing between
the UK and the US and ran both jobs
simultaneously.

Our work with ADT is wide-ranging:
from annual reports for Belize Holdings
Inc., of which ADT's Michael Ashcroft is
also Chairman, to the signage, stationery
and student uniforms for the ADT City
Technology College in London.

Document specification
Format 21.5 x 28.0cm
52 pages
90,000 copies

161

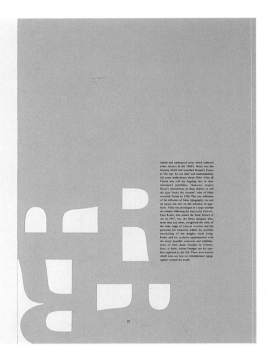

The text body columns for pages 26 and 27 are illegible at this resolution.

*'i am of the opinion that it is possible to develop
an art largely on the basis of mathematical thinking'*

26

27

designer
Jason Carr

college
The Surrey Institute of
Art & Design, Farnham

country of origin
UK

work description
Spreads proposed for
Baseline magazine

dimensions
267 x 360 mm
10¹⁄₂ x 14¹⁄₈ in

162

*'concept should be expressed with greatest
economy - optically not phonetically'*

22

23

designer
Viviane Schott

college
The Surrey Institute of
Art & Design, Farnham

country of origin
UK

work description
Cover and spread from
Area 39, a magazine
project covering
experimental music,
design, and multimedia

dimensions
210 x 297 mm
8¼ x 11¾ in

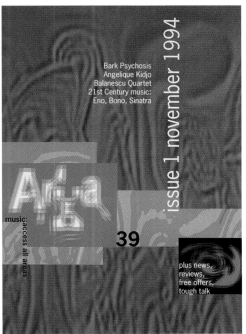

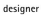

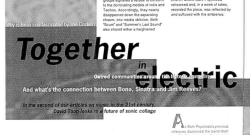

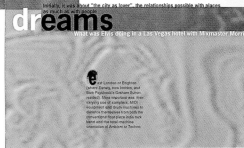

designers
Mark Diaper
Rachael Dinnis
Mike Davies
Domenic Lippa
Marcus "mad dog" Doling
Jann Solvang

design company
Lippa Pearce Design
Limited

country of origin
UK

work description
Front cover and spreads
from *The Downlow*, the
Hip Hop magazine

dimensions
210 x 297 mm
8¼ x 11¾ in

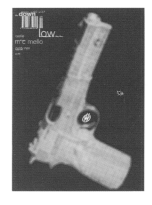

164

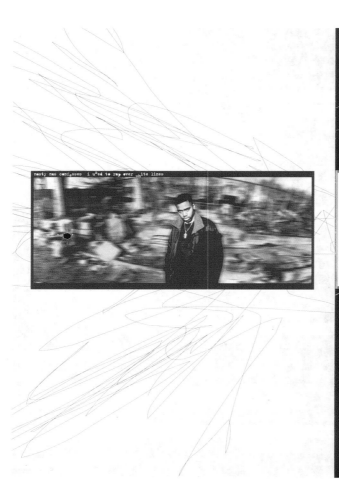

nasty nas confuses i u^sed to rap over white lines

STAIN-

less meets Coolio.

Tommy Boy's West Coast Rapper who claims: I knew your Queen when she was working at the K-Mart in Compton and we called her 'Q'. COOLIO has been under the skin of West-Coast Hip-Hop since it began. He was brought up in Compton, became a member of the Crips - and a Krack addict. He learnt his trade on the streets, which he came to know intimately, initially by-passing the recording studios of the district. You could say his background is typical of just another everyday Gangsta Rapper at the start of his career. But Coolio doesn't want to use this route to establish himself. Maybe it's because he knows the streets all too well. His debut album for Tommy Boy, 'It Takes A Thief', skips in and around that dark territory, but never comes off as a fully-fledged Gangsta album. Why's that? "Cos I'm a realist, man. I'm a reality-Rapper. Coolio tells me. 'Gangsterism is only a part of my life. I don't use it as the basis of what I do. What I do comes from real Hip-Hop. That's what I'm about. Gangsta Rap is cool, but I'm not really a Gangsta.' As we talk Coolio becomes my guide for a tour of the Hood and what happens there; how things run and what Krack is all about. Born with a heart made of celluloid, I'm studying to become a film director and so I listen to Coolio's commentary and visualize what he describes. His words become an outline for the kind of motion-picture I'd like to make; a story that's weird, remarkable and packed full of dramatic content.

Read on now and follow Coolio as he introduces us to the Gangs, Krack, Ugly Bitches...and Pigs.

"I've always been known as a Rapper. I only gang-banged for a little while. See, if a muthafucka fucked with me I'd fuck with him. But let me tell you what happened. I met two of the craziest muthafuckas on the planet. Two brothers called Goldie and Iptu. These muthafuckas, boy, would [...] death. They was crazy. One day they robbed this muthafucka and because he didn't have any money, they killed him. They hit him in the head with the back end of a hammer. I saw them putting holes in his skull. It was like, damn nigga! I started to throw up. I'd never seen that shit before. So the next day I moved on. That shit wasn't for me. I started lookin' at life in a different way. I started to learn more about my history. About how things are really supposed to be. See, when I was gangbangin' we used to fist-fight. Somebody might get stabbed, but muthafuckas weren't just killin' each other. For me, Gangs were a necessity. It was for protection. 'Coz I was the only child and I was the only one at home. I didn't have nobody to back me up when I got in trouble. So I just started runnin' with the gangs for protection. But the gang situation is unstoppable. The gangs have been going for 40 years, man. See, the way the Gangs are organized, you're only as strong as the strongest person in your gang. The smartest muthafucka in your gang. If your shot-caller is a stupid ignorant, a do-anything muthafucka, then your gang is gonna be like that. But. If you've got a smart calculative muthafucka runnin' your shit, then your gang is gonna be smart too, and your hood will make money. But it's not really all about money. It's for protection and territory. Territory is what it's all about. Don't come over here sellin' your dope in my hood and I might not come in your hood, but if you come over here it's on. And now it's moved over to this Colors thang. When it started it wasn't really about Colors. It was just muthafuckas kickin' it. There wasn't any Bloods, it was all Crips. Crip actually. It originally stood for Consolidated

THEY'RE BULL-SHIT NOW." COOLIO on the Gangs.
"Black Cop/ White Cop / Fuck the color of his skin/ make sure he's shot."
"Bring Back Somethin' Fo Da Hood"

Republic Independent Party. It was a southern Californian division of The Black Panthers. Then something happened at a party, I think some people got killed, and the Crips were blamed. So these muthafuckas were like, "Fuck the Crips! We gonna beat them!". So that's how it ran and the Bloods were created. For instance, if I killed your brother, you and me are gonna be enemies forever, right? You gonna wanna kill me, right? So this shit has been has been going on for 40 years. The gangs who have been going on the longest have been the Mexican gangs and the Hispanic gangs. They were around before the Crips. But it don't really matter where you're from or who you are. You fight anybody who comes in ya hood. It's all about money and territory. But when I was comin' up, if you was a Crip you would get a pass. But now Crips don't give a fuck about Crips. It started off as something positive for a lot of people. But somehow it got twisted. It started off as something real, something positive that could have helped my people. But somehow it got twisted and turned into some bull-shit. So all the shit I grew up on and knew turned out to be bull-shit. Because none of that shit is helping anybody. If you're not part of the solution then you're part of the problem. And the gang situation is one big problem. That Gang-truce was bull-shit. It lasted three weeks. Actually it lasted the whole summer, but after that, muthafuckas were getting killed again. After they ran out of beer [...] shit was on [...] brain [...] you only heard "Colors" came out. That's what fucked

everything up. Because before "Colours", gangbangin' was only in California. After that film came out, muthafuckas started bangin' in Kansas and fucked-up places like Nebraska. There's even a gang of White Crips! Places up in the stix, which have no reason what-so-ever to be fighting are bangin' homie. Hard bangin'. Do or die, brother. Let me tell you about the South. The South is where the slave trade began. They were the last States to stop the slave trade. They saw all the other States didn't have slaves and they thought "Fuck that! We're keepin' our muthafuckin' slaves!". And that's what the Civil War was about. So the Southern Blacks have a lot more history than the other Blacks. Therefore any

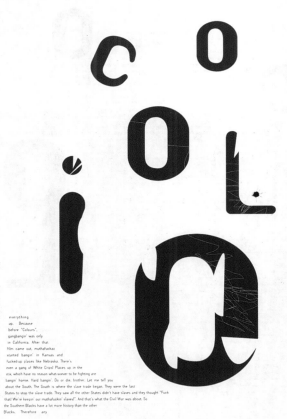

165

designers
Alessio Leonardi
Harald Welt

photographer
Frank Thiel

art directors
Uli Hoyer
Guenther Fannei

design company
Meta Design plus GmbH

country of origin
Germany

work description
Front cover and spreads
(center with gatefold)
from *Hauptstadtformat*, a
brochure for Grundkredit
Bank

dimensions
204 x 270 mm
8 x 10⅝ in

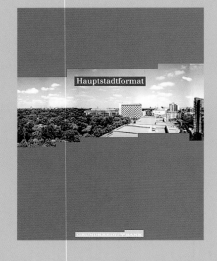

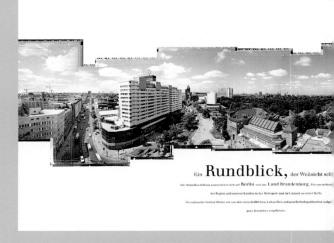

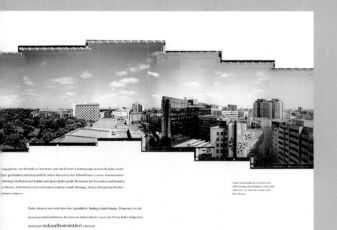

engagieren uns deshalb im Interesse und mit breiter Zustimmung unserer Kunden mehr ... ihre persönlich und finanziell in vielen Bereichen des öffentlichen Lebens. Insbesondere ... ferung von Kunst und Kultur und Sport findet große Resonanz bei Freunden und Kunden ... s Hauses. Erhebliches Gewicht haben zudem soziale Belange, denen wir uns mit Förder... chmen widmen.

Dabei denken wir weit über das eigentliche Bankgeschäft hinaus. Denn nur wo die gesamtgesellschaftliches Strukturen harmonisieren, kann die Wirtschaft erfolgreich, stabil und **zukunftsorientiert** arbeiten.

Unter Zusammenblick von Dach der GKB Zentrale gen... langen (auf den Seiten 14 - 17) über die Grenzen der Stadt hinaus.

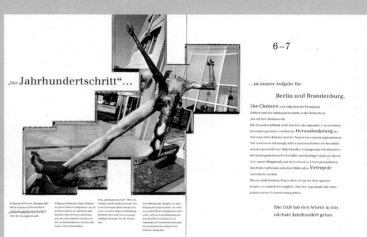

„Der Jahrhundertschritt"...

...ist unsere Aufgabe für **Berlin und Brandenburg.**

Die Chancen und Aufgaben der Deutschen Einheit sind ein Jahrhundertschritt an der Schwelle in das nächste Jahrtausend.

Die GrundKreditBank sieht sich hier als regionales Unternehmen besonders gefordert und hat die **Herausforderung** im Interesse ihrer Kunden und der Region aufgenommen. Wir sind davon überzeugt, daß es im wesentlichen die Investitionen des gewerblichen Mittelstandes, vermögender Privatkunden, der leistungsbereiten Freiberufler und Bauträger sind, mit denen sich unsere Hauptstadt und das Umland zu einer prosperierenden Wirtschaftsmetropole mit einer blühenden **Metropole** entwickeln werden.

Diesen nicht leichten Weg wollen wir an der Seite unserer Kunden so schnell wie möglich, aber mit Augenmaß und unternehmerischer Verantwortung gehen.

Die GKB hat den Schritt in das nächste Jahrhundert getan.

Wolfgang Mattheuer, Jahrgang 1927, lebt in Leipzig und Reichenbach. „Jahrhundertschritt" 1984/85, Leipziger, bemalt.

Wolfgang Mattheuer, Maler, Bildhauer und zeichner Zeitgenosse, ist seit je überzeugt davon, daß Kunst und Künstler dem Betrug leisten müssen, dem menschlichen Glauben an die Verletzbarkeit des Lebens zum Guten aufrechtzuerhalten.

Seine „Jahrhundertschritt" 1984 entstanden, macht auf eindrucksvolle Weise den Zwiespalt menschlicher Existenz zwischen Angst und Hoffnung deutlich und wurde so zur aussagekräftigen Metapher für die Wende ...

Seit 1989 steht die Skulptur vor dem Eingang der GKB Zentrale: als zeitloses Symbol für die Fähigkeit des Menschen, sich nach Unterdrückung und Gewalt befreien zu können, als Mahnmal zur Nachdenklichkeit und als Zeichen für die schöpferische Kraft des Vorwärts.

167

designer
Geoff White

art director
Geoff White

design company
Ilex Marketing Graphic
Design Unit

country of origin
UK

work description
Spreads from a brochure
for Teal Furniture

dimensions
210 x 297 mm
8¼ x 11¾ in

designer
Neil Walker

art director
Nicholas Thirkell

design company
CDT Design Ltd

country of origin
UK

work description
Spread from issue one
of *Transformation*, a
publication for Gemini
Consulting

dimensions
237 x 297 mm
9⅜ x 11¾ in

12

My generation welcomed Porter. We thought we had written his book, "Competitive Strategy". His approach was refreshing, after leveraged betas, and second and third derivatives. We loved the return of a business perspective, in the tradition of matrix-based models. We were back to civilization. It was music we could play.

It was also an analytical heaven. The five forces model gave us latitude to go study *everything* - competitors, customers, suppliers, technologies and that magnificent excuse for analytical excess, "potential entrants" (which could include my grandmother, and the Boston Red Sox). Consulting budgets became very large indeed.

Porter's five forces are still useful for capturing industry data, the value chain remains a work horse of strategic analysis, but the generic strategies, and the U-shaped curve have not aged well. They've been branded with the label, "ex post" because they explain what happened but lack predictive power. As Gary Hamel (see below) once uncharitably put it, Porter's model is to business success, what Biblical exegesis is to sainthood. You can study it all you want, but you'll never get there.

From strategic rock 'n' roll to transformational polyphony

After Porter, I knew that things would never be the same, so I decided to look for the real me. I left my rock group, and moved to America.

In summer, 1989, I went to a concert in Ann Arbor, Michigan. The band was called Strategic Intent and Core Competencies, and featured C.K. Prahalad, from the University of Michigan, and Gary Hamel, his former student, from the London Business School. The music magazines billed the new band, *sixth generation*.

> "Porter's model is to business success, what Biblical exegesis is to sainthood."

In America, but not yet in continental Europe, the wind went out of shareholder value's sails. The well of junk bond cash ran dry. Our deal-making went the way of John Travolta. We swapped our white disco suits, for Calvin Klein jeans. Icahn and Perelman became sedate businessmen.

Shareholder value has been absorbed into a broader approach. It remains the best representation of the owner's point of view, and that is becoming a precious quality again, at a time when boards are intent on becoming players in the game, rather than decorative wallpaper. And it has found a niche in compensation. If the job of executives is to create value, why not tie their compensation to the value they create for shareholders?

After the first shareholder value wave (there've been others and there will be more) came the new sound of Michael Porter (*fifth generation*). This marked the return of Harvard Business School as the great strategy studio, and a switch from a great sound of Michael Porter (fifth generation). This tighter, the music more symphonic. The Police replaced the Who. My keyboard soon resembled a helicopter's control panel.

Porter had been a Federal Trade Commission regulator, but he switched sides and, instead of policing oligopolies and monopolies, he began helping companies, and later countries, to shape their industry structure to their own advantage (within those regulatory limits, of course).

"Why does the pharmaceutical industry make money but the OEM tyre business does not?" he asked. "Because there are five forces which determine the profitability of industries" he explained. Executives began buying his records. Some bought the video for their daughters. He also showed that low-cost strategies were not always appropriate, and so demolished 20 years of Boston Consulting Group dogma.

Porter suggested differentiation and focus as strategies and he revamped the clumsy cost structure approach as the "value chain". The look became more formal. Sting rather than Alice Cooper.

13

I'd never heard anything like it. The approach was a strange mixture of analytical rigor and mysticism, a blend of old-fashioned beat and oriental influences. Although confused by the multi-layered message, I spotted the brilliant strategic prescription. Instantly, I knew they would change my life.

"All the prescriptions of traditional strategic models are fundamentally flawed" Prahalad and Hamel claimed, "because they rely on some kind of segmentation. As a result, each entity fights as a standalone division, rather than as part of an army. That is why the Japanese have destroyed Western rivals over the last 20 years; Cannon versus Xerox, Komatsu versus Caterpillar, and Toyota and Honda versus Ford and GM."

The model uses a botanical metaphor. Each core competency is a root of a tree, and each business, a fruit on the upper branches. The fruit becomes abundant, and succulent, through the nurturing of the roots. The sap rises, promoting growth in the branches, and yielding the lucrative harvest of which business success is made.

Traditional methodologies are flawed because they pump water directly into the fruit, rather than the roots. The tree is the "strategic architecture" and the firm's ambition is its "strategic intent".

I became a disciple. I searched for strategic intent with my clients. I discovered their tree metaphor was just that, a metaphor. What mattered was the search. In seeking strategic intent, firms would learn to mobilize their energies. They would begin growing again after decades of contraction. They would reach for higher ground; raise their sights. And, as if by faith healing, their performance would begin to improve.

I felt the power of strange words: like "change management", and "mobilization".

But I was not convinced. "This can't be" I protested. "There must be an analytical key, hidden behind the metaphor". But the more I looked, the more certain I became there was no secret key. Even so, there was something to this mysticism. The unfathomable Orient was bewitching me. The right side of my brain was taking over the left.

About a year later the world of Market-Focus entered my life (*seventh generation*). My first reaction was that I had heard all this before. "Yeah" I thought, "customer stuff. Old marketing soups, warmed up." It felt like the Rolling Stones attempting a come-back with Mick Jagger at 50.

> "...by jumping several steps down the value chain, we could reinvent businesses and their margins."

But, as I listened to Lynn Phillips and Mike Lanning - the arch-priests of "Building Market-Focused Organizations" - I became intrigued. I had worked a lot with commodity chemical companies (this interest could be traced back to my penchant for weird substances in my rock 'n' roll days), but I had never managed to sell them differentiation. "When you make ethylene oxide, there ain't much you can do, son", a Union Carbide manager had told me.

Phillips and Lanning thought otherwise. And they were right. We invented a strange verb: to "decommoditize". We learned that by jumping several steps down the value chain, we could reinvent businesses and their margins.

Our market-focus workshops developed a following. Companies embarked, with us, on quests for new Value Propositions. We invented "on-line strategy" - making up stuff right there, in front of clients and their customers. I discovered the power of live improvisations - creating business success in collective jam sessions. And because clients saw it unfold, in front of their eyes, it was hard for them to discount, or ignore. "Change management" and "mobilization" were back, in their second incarnation.

It was time for my mid-life crisis. I had survived, more or less intact, seven strategic generations. I had moved from my piano, to electronic orchestras; from carefully crafted singles, to unbridled, live improvisations. I'd been shaken to my analytical foundations many times, and been confused

169

designers
Simon Browning
Yumi Matote

photographer
Richard J. Burbridge

art director
Adam Levene

design company
Cartlidge Levene Limited

country of origin
UK

work description
Front covers from *Visions*
and *Focus*, a two-part
recruitment brochure for
Shell International

dimensions
210 x 297 mm
8¼ x 11¾ in

designers
Simon Browning
Helge Kerler
Yumi Matote

photographers
Tomoko Yoneda
Library Images

art director
Ian Cartlidge

design company
Cartlidge Levene Limited

country of origin
UK

work description
Spread from a large
format version of *Visions*,
a recruitment brochure
for Shell International

dimensions
297 x 420 mm
11¾ x 16½ in

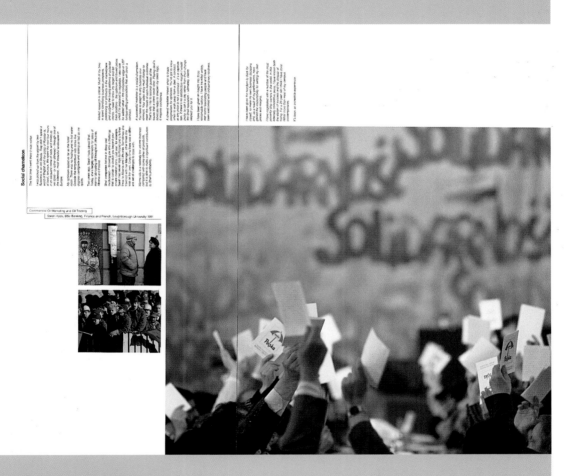

designer
Erik Spiekermann

design company
Meta Design, San
Francisco

country of origin
USA

work description
Front cover and spreads
from *Stop Stealing Sheep*
(self-published)

dimensions
143 x 215 mm
5⅝ x 8½ in

172

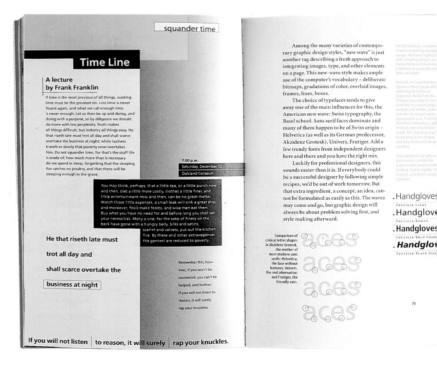

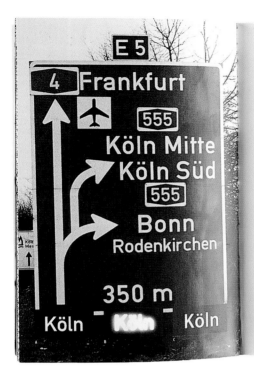

Some of the most pervasive typographical messages have never really been designed, and neither have the typefaces that appear on them. Some engineer, administrator, or accountant in some government department had to decide what the signs on our roads and freeways should look like. This person probably formed a committee made up of other engineers, administrators, and accountants who in turn went to a panel of experts that would have included manufacturers of signs, road safety experts, lobbyists from automobile associations plus more engineers, administrators, and accountants. You can bet there wasn't one typographer or graphic designer in the group, so the outcome shows no indication of any thought toward legibility, let alone communication or beauty. Nevertheless we're stuck with our road signs. They dominate our open spaces, forming a large part of a country's visual culture.

The letterforms on these signs were constructed from simple geometric patterns rather than from written or drawn letterforms because they had to be re-created by signmakers all over the country. It seems our official alphabets are here to stay, even though it is feasible to use other typefaces more suitable for the task.

DIN (Deutsche Industrie-Norm=German Industrial Standard) is the magic word for anything that can be measured in Germany, including the official German typeface, appropriately (and not surprisingly) called DIN-Schrift. Since it's been available in digital form, this face has been picked up by many graphic designers who like it for its lean, geometric lines, features that don't make it the best choice for complex signage projects.

Signage systems have to fulfill complex demands. Reversed type (e.g., white type on a blue background) looks heavier than positive type (e.g., black on yellow), and back-lit signs have a different quality than front-lit ones. Whether you have to read a sign on the move (from a car, for example), or while standing still on a well-lit platform, or in an emergency – all these situations require careful typographic treatment. In the past these issues have been largely neglected, partly because it would have been almost impossible to implement and partly because designers chose to ignore these problems, leaving them up to other people who simply weren't aware that special typefaces could help improve the situation.

Multiple master typefaces (see pages 109–111) like Minion and Myriad can be tuned to every lighting condition and production specification. The PostScript™ data generated with these types in drawing and layout applications can be used to cut letters of any size from vinyl, metal, wood, or any other material used for signs.

Soon there will be no more excuses for badly designed signs, whether on our roads or inside our buildings.

A DIN-Schrift, reversed out.
B Type on back-lit sign suffers from radiant light.
C More explicit letter shapes help (o is more oval, i-dots are round).
D But still, backlighting presents a problem.
E The type has to be just a little lighter, so that finally …
F It is more legible than in example B.

D

E

F

The tricky thing about space is that it is generally invisible and therefore easy to ignore. At night you can see only as far as the headlights of your car can shine. You determine your speed by the size of the visible space in front of you.

While driving on freeways isn't quite as exhausting as running a marathon (mainly because you get to sit down in your car), it requires a similar mind-set. The longer the journey, the more relaxed your driving style should be. You know you're going to be on the road for a while, and it's best not to get too nervous, but sit back, keep a safe distance from the car in front of you, and cruise.

Long-distance reading needs a relaxed attitude, too. There is nothing worse than having to get used to a different set of parameters every other line: compare it to the jarring effect of a fellow motorist who suddenly appears in front of you, having jumped a lane just to gain twenty yards. Words should also keep a safe, regular distance from each other, so that you can rely on the next one to appear when you're ready for it.

It used to be a rule of thumb for headline settings to leave a space between words that is just wide enough to fit in a lowercase i. For comfortable reading of long lines, the space between words should be much wider. The default settings in most software vary these values, but the normal 100 percent word space seems just fine for lines of at least ten words (or just over fifty characters). Shorter lines always require tighter word space (more about that on the following page).

The way to wealth

If time be of all things the most precious, wasting time must be the greatest prodigality, since lost time is never found again, and what we call time enough always proves little enough. Let us then be up and doing, and doing to a purpose, so by diligence we should do more

If time be of all things the most precious, wasting time must be the greatest prodigality, since lost time is never found again, and what we call time enough always proves little enough. Let us then be up and doing, and doing to a purpose, so by diligence we should do more

A lowercase i makes a nice word space for headlines. Short lines should have modest space between the words.

123

designer
John O'Callaghan

college
Ravensbourne College
of Design and
Communication,
Chislehurst

tutor
Barry Kitts

country of origin
UK

work description
Spreads from a proposed
monthly digest of the
weekly magazine *The New
Scientist*

dimensions
210 x 297 mm
8¼ x 11¾ in

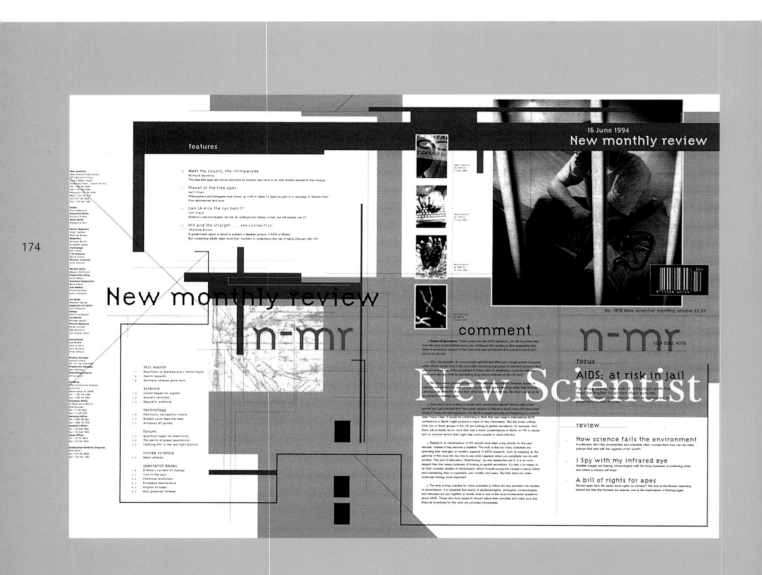

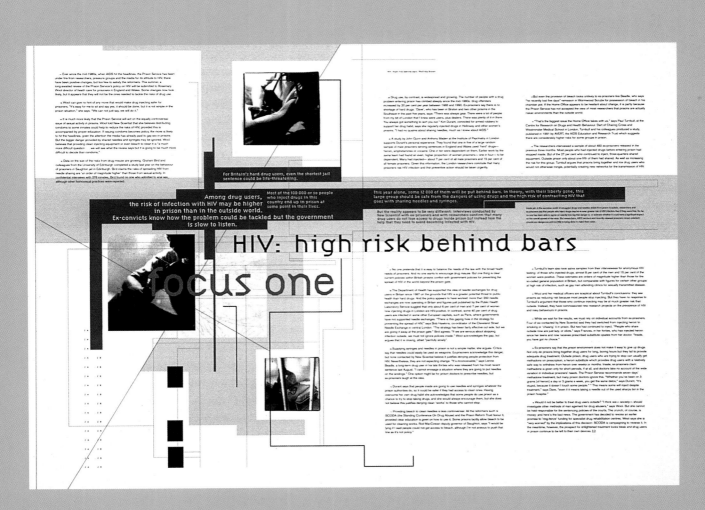

For Britain's hard drug users, even the shortest jail sentence could be life-threatening.

Among drug users, the risk of infection with HIV may be higher in prison than in the outside world. Ex-convicts know how the problem could be tackled but the government is slow to listen.

Most of the 100 000 or so people who inject drugs in this country end up in prison at some point in their lives.

This year alone, some 12 000 of them will be put behind bars. In theory, with their liberty gone, this large group should be safe from the dangers of using drugs and the high risk of contracting HIV that goes with sharing needles and syringes.

But the reality appears to be very different. Interviews conducted by New Scientist with ex-prisoners and with researchers confirm that many drug users do not lose access to drugs inside prison but instead lose the help that they need to avoid becoming infected with HIV

HIV: high risk behind bars

focus one

designer
P. Scott Makela

photographers
P. Scott Makela
Rik Sferra
Alex Tylevich

art director
P. Scott Makela

design company
Words and Pictures for
Business and Culture

country of origin
USA

176

work description
Front cover and spreads
from a catalog/prospectus
for Minneapolis College
of Art and Design

dimensions
215 x 292 mm
8½ x 11½ in

MCAD students are eager to experiment.

INVENT, DISCOVER, WORK HARD, BE THEMSELVES, REACH FOR THE STARS. THEIR DETERMINATION AND CURIOSITY HEAT UP THE STUDIOS AND LIGHT THE LABS AT THE MIDNIGHT HOUR. "THE STUDENTS HAVE AN INTERNAL NECESSITY TO MAKE ART AND A GREAT RESPECT FOR ART." *HAZEL BELVO, CHAIR, FINE ARTS DIVISION.* Students come to MCAD from many different backgrounds and experiences, from coastal cities, urban centers and rural towns across the United States and in twenty foreign countries, including Japan, Thailand, Italy and Norway. They come from high school, community colleges, former jobs and former lives. They are committed to their art and their future role as artists and designers in society, and are highly motivated, culturally aware, and ready to take a stand on issues important to them. Passionate about their education, their central mission is to live and work as visual artists. "WE HAVE A ROMANTIC VISION THAT WE ARE MAKING A CHANGE IN THE WORLD. WE ARE ARTISTS WHO ARE VERY SOCIALLY INVOLVED, PARTICIPATING IN SOMETHING BIGGER THAN JUST COMING TO CLASS OR HAVING PIECES IN A SHOW." *IVAN NUNEZ '90, FINE ARTS, MARACAIBO, VENEZUELA.* "GOING TO ART SCHOOL IS ABOUT BECOMING CAREFUL VIEWERS. THE MORE ATTENTION WE PAY TO OUR SURROUNDINGS, THE MORE WE CAN LEARN FROM AND APPRECIATE THEM." *MARIAM STEPHAN, FINE ARTS, PITTSBURGH, PENNSYLVANIA.* "THERE ARE SUCH TALENTED AND KNOWLEDGEABLE PEOPLE HERE — STUDENTS, TEACHERS, STAFF, EVERYONE. THERE'S INTELLECTUAL DISCUSSION EVERYWHERE, DISCUSSION ABOUT THE ARTS, CHOICES WE MAKE, HOW YOU LIVE YOUR LIFE" *ROSEMARY RISKIN '93, FINE ARTS, MINNETONKA, MINNESOTA.* MCAD teachers — filmmakers, photographers, graphic designers, fine artists — bring the riches of their own work to the classroom. Their connections sometimes lead to internships, artist apprenticeships and jobs for students. Most of MCAD's faculty have advanced degrees in their fields from the nation's top graduate programs. Students cite faculty as one of MCAD's greatest strengths, not only for their talent and teaching skills, but also because they're such great people. "MY TEACHERS HAVE BEEN JUST INCREDIBLE! THEY HAVE HELPED ME FOCUS ON WHAT I WANT AND THE DIRECTION I WANT TO GO. THEY HAVE ENCOURAGED ME TO TRY DIFFERENT THINGS — TO GO OUT THERE AND GET MY HANDS DIRTY." *HEATHER PALMER, FOUNDATION STUDIES, STUDIO CITY, CALIFORNIA.* "THE INSTRUCTORS ARE SO COMMITTED TO THEIR COURSES AND THEIR STUDENTS THAT IT DEVELOPS A SENSE OF COMMITMENT IN YOU." *EDMUND ASHLEY, FOUNDATION STUDIES, PORTLAND, MAINE.* Visiting artists stimulate the MCAD environment by teaching courses, giving critiques and public talks and showing their work. Recent visitors included environmental artists Helen Mayer Harrison and Newton Harrison, graphic designer Anthon Beeke from Holland, and photographer Annie Leibovitz. Alumni frequently visit classes to answer your questions about work opportunities in the visual arts and how to prepare for specific careers.

Facilities

Computer Center

Computers are powerful tools that enable designers and artists to explore visual solutions to assignments and production works. They also expand creative horizons and amplify imagination and visual exploration. Although computers make it possible to view more alternatives with great speed, the final image must be the product of a skilled artist's mind and spirit. Computers are utilized by MCAD students in all areas of study. Classes in the Design major incorporate the use of computers in graphic design, package design, furniture, and interactive design. Media Arts students use computers for video editing, electronic photography, and sound composition. 3D modeling programs are applied to sculpture projects; painting and drawing students explore the large array of color painting and illustration software. Computers at MCAD are not just a technical tool, they are a medium for creative expression.

Whether your interest lies in image composition, digital media (video, sound and photography), color painting, 3D modeling and animation, or graphic design and illustration, MCAD's Computer Center puts at your fingertips an incredible range of the latest hardware and software. Color painting and image composition needs are met from our collection of eight paint programs. You can choose from four animation programs, seven drawing and illustration programs, eleven 3D design and modeling programs, three image manipulation programs, four page design and related applications and dozens of other specialized pieces of software. There are plenty of spaces (more than 120 work-

designer
P. Scott Makela

photographers
P. Scott Makela
Rik Sferra
Alex Tylevich

art director
P. Scott Makela

design company
Words and Pictures for
Business and Culture

country of origin
USA

178 work description
Spread from a catalog/
prospectus for
Minneapolis College
of Art and Design

dimensions
215 x 292 mm
8½ x 11½ in

"If there is an
you are going
of being an art
It's a very hun
ence and it's r
But you will a
if you come wi
work and the
artist and a cr

place where
feel the joy
t, it's here.
ling experi-
lly hard work.
ieve success
the desire to
ve of being an
tive person."

Barbara Beshoar, Design, St. Paul, Minnesota

designer
Denise Gonzales Crisp

college
California Institute of
the Arts

country of origin
USA

work description
Spreads from *A Sign in
Space*, an interpretation
of a story by Italo Calvino

dimensions
270 x 340 mm
10⅝ x 13⅜ in

things were different, ...er, because the world ... I mentioned, was ...ning to produce an ... of itself, and in ... of that galactic year ...thing a form was ...ning to correspond to a ... we already began to ...ion, and forms of that ... realize that the ... world's forms had been ...we believed, had a long ... temporary up until ...e ahead of them ... then, and that they ...ead, we were wrong: ... would change, one by ...to give you a fairly ... one. And this awareness ...t example, the ... was accompanied by a ...aurs), and therefore in ... certain annoyance with ...new sign of mine you ... the old ...perceive the ... images, so ...ence of our ... that even ...ay of looking ... their memory ...ings, call it ... w a s ...if you like, ... intolerable. I ...special way ... began to be ...everything ... tormented by a ...to be, there, ... thought: I had left ...a certain ... that sign in space, ...on. I must say ... that sign which had ...was truly ... seemed so beautiful and ...fied with it, ... original to me and so ...I no longer ... suited to its function, ...tted that ... and which not, in my ...sign that had ... memory, ... erased, ... inappropriate, in all its ...se this one ... pretension, a sign chiefly ...d vastly more ... of an antiquated way of ...ful to me. ... conceiving signs and of my ...n the duration ... foolish acceptance of an ... order of things I ought to ... have been wise enough to ... break away from in time. In

other words, I was ashamed of that sign which went on through the centuries, being passed by worlds in flight, making a r i d i c u l o u s spectacle of itself and of me and of that temporary way we had had of seeing things. I blushed when I remember it (and I remembered it constantly), blushes that lasted whole geological eras: to hide my shame I crawled into the craters of the volcanoes, in remorse I sank my teeth into the caps of the glaciations that covered the continents. I was tortured by the thought that Kgwgk, seemed always preceding me in the circumnavigation of the Milky Way, would see the sign

before I could erase it, and boor that he was, he would mock me and make fun of me, c o n t e m p t u o u s l y repeating the sign in rough caricatures in every corner of the circumgalactic sphere. Instead, this time the complicated astral time keeping was in my favor. K g w g k ' s constellation d i d n ' t encounter the s i g n , whereas our solar system turned up t h e r e punctually at the end of the f i r s t revolution, so close

I conceived the idea of making a sign, that's true enough, or rather, I conceived the idea of considering a sign a something that I felt like making, so when... that point in space and not in another, I made something, meaning to make a sign it turned out that I really had made a sign, after all

...it differences, there were no things to copy, nobody knew what a line was, straight or curved, or even a dot... In other words, considering it was the first sign ever made

designers
Mark Diaper
Domenic Lippa

design company
Lippa Pearce Design
Limited

country of origin
UK

work description
Front covers and spread
from *Now You See It*, a
series of catalogs for six
performances given at the
South Bank Centre,
London; the cover
material changed each
night (above, from left to
right: corrugated plastic,
latex, paper, corrugated
cardboard, sandpaper,
paper)

dimensions
300 x 250 mm
11⅞ x 9⅞ in

182

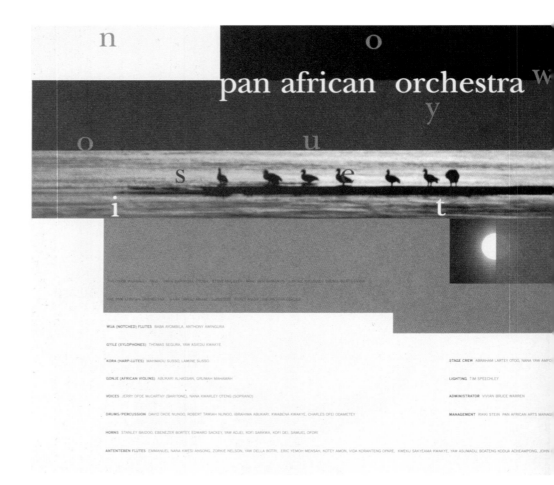

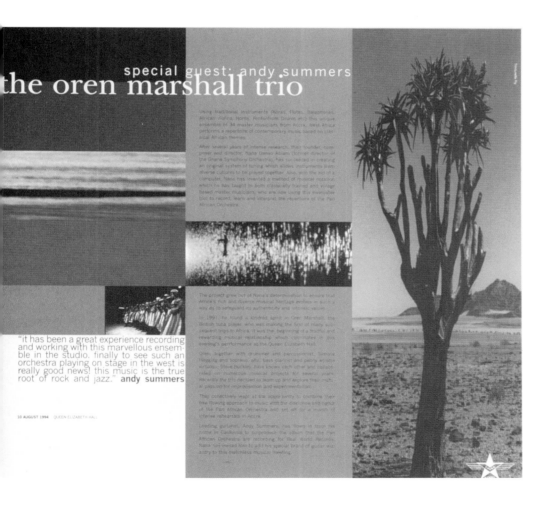

the oren marshall trio

Using traditional instruments (Koras, Flutes, Balaphones, African Violins, Horns, Fontomfrom Drums etc) this unique ensemble of 34 master musicians from Accra, West Africa performs a repertoire of contemporary music, based on classical African themes.

After several years of intense research, their founder, composer and director, Nana Danso Abiam (former director of the Ghana Symphony Orchestra), has succeeded in creating an original system of tuning which allows instruments from diverse cultures to be played together. Also, with the aid of a computer, Nana has invented a method of musical notation which he has taught to both classically trained and village based master musicians, who are now using this invaluable tool to record, learn and interpret the repertoire of the Pan African Orchestra.

The project grew out of Nana's determination to ensure that Africa's rich and diverse musical heritage endures in such a way as to safeguard its authenticity and intrinsic values.

In 1991 he found a kindred spirit in Oren Marshall, the British tuba player, who was making the first of many subsequent trips to Africa. It was the beginning of a fruitful and rewarding musical relationship which culminates in this evening's performance at the Queen Elizabeth Hall.

Oren, together with drummer and percussionist, Simeon Hogarty and toothless alto, bass clarinet and piano virtuoso, Steve Buckley, have known each other and collaborated on numerous musical projects for several years. Recently the trio decided to team up and explore their musical passion for improvisation and experimentation.

They collectively leapt at the opportunity to combine their free flowing approach to music with the discipline and rigour of the Pan African Orchestra and set off for a month of intense rehearsals in Accra.

Leading guitarist, Andy Summers, has flown in from his home in California to superintend the album that the Pan African Orchestra are recording for Real World Records. Nana has invited him to add his special brand of guitar artistry to this matchless musical meeting.

"it has been a great experience recording and working with this marvellous ensemble in the studio. finally to see such an orchestra playing on stage in the west is really good news! this music is the true root of rock and jazz." **andy summers**

10 AUGUST 1994 QUEEN ELIZABETH HALL

183

designer
Ulysses Voelker

art director
Ulysses Voelker

design company
Meta Design plus GmbH

country of origin
Germany

work description
Front cover case binding
and spreads from
*Zimmermann meets
Spiekermann*; the book
is concertina-folded
allowing text to be seen
through the translucent
paper which is printed
on both sides, published
by Hochschule für Künste

dimensions
213 x 280 mm
8¾ x 11 in

184

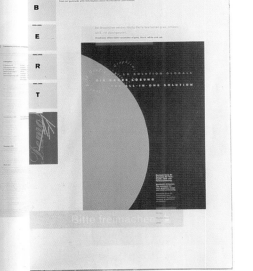

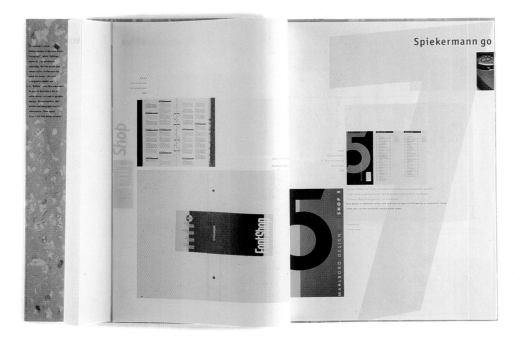

Spiekermann go

designer
Koeweiden/Postma
Associates

photographer
Marc van Praag

country of origin
The Netherlands

work description
Front cover case binding
and spreads from the
book *Architecten*,
volume 1, for Bis
publishers

dimensions
250 x 300 mm
9⅞ x 11⅞ in

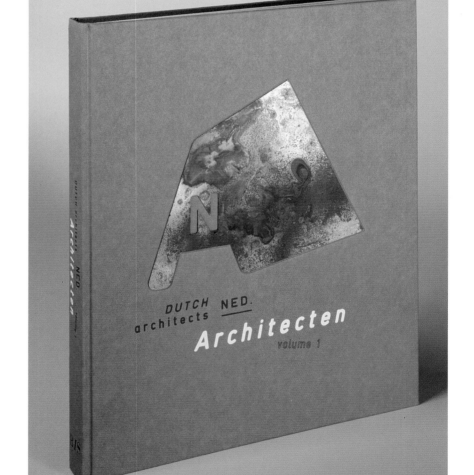

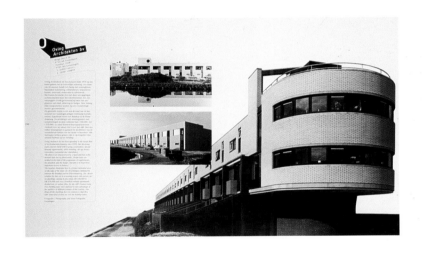

Oving
Architekten bv

[address block — illegible]

[body text — illegible]

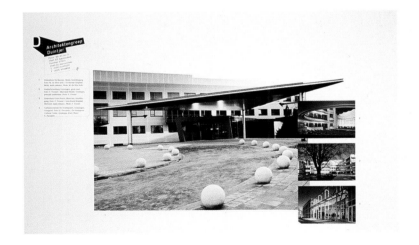

Architektengroep
Duintjer

[address block — illegible]

[caption text — illegible]

designer
Loïc Lévêque

photographers
Bobby Adams
Erich Huller
Loïc Lévêque

design company
Loïc Lévêque Design

country of origin
France

work description
Spread and front cover of
an experimental magazine
on Industrial Music (self-
published)

dimensions
276 x 370 mm
10⅞ x 14½ in

188

Ce pays
fonctionne encore
comme dans les années 1870,
où tout était fondé sur le travail.
Pendant plus de 100 ans, ils ont conditionné et
éduqué le peuple dans un ordre moral très rigide. Les
heures d'ouverture des bars, des restaurants etc, sont réglés sur
le temps de travail. Tout ferme tôt, pour que le peuple puisse se lever
de "bonne heure" pour travailler. On vit encore le rêve du 19 eme siècle. Si on
ne travaille pas, on ne sert moralement à rien. On n'est pas digne, on ne peut pas
avoir une place dans cette société. Maintenant, ils ont toute une génération de chomeurs. On
nous a tous appris que les chomeurs étaient des lèpreux. C'est pour ça que le pays est dans la merde. Il va fal-
loir qu'on les déconditionne. Il existe cette génération folle de gosses qui ont appris à l'école que leur seul rôle dans la vie
c'est de se justifier, donc de travailler. Puis en sortant de l'école, ils se rendent compte qu'il ne travailleront jamais. C'est une
génération psychotique. Nous n'y appartenons pas, bizarrement, mais on a grandi ensemble, nous la comprenons. Je suppose qu'ils
reconstruiront les maisons des pauvres et tout recommencera, le pays redeviendra celui de Dikens... Vous avez des obsessions ou
des intérêts personnels ? Je crois que si un intérêt devient une obsession ça fait très artificiel. C'est devenu chic, d'être obsédé
par quelque chose que les autres trouvent dégueulasse.. Certains estiment que la fascination du mal renie toute moralité
bourgeoise, mais il me semble qu'aller à l'extrème deviendrait une sorte de snobisme. J'appellerais mes obsessions "fascina-
tions curieuses", pas obsession. Nous sommes très intéressés par les rythmes, en ce moment. Nous sommes des primi-
tifs urbains. On est facsiné par les primitifs ethniques . Je ne dis pas qu'on soit un groupe ethnique, mais on
est conscient (comme les musiciens Jajoukas) de cette force primitive. On ne les imite pas, on
est des primitifs modernes. Je ne crois pas qu'on essaye de l'être, on est natu-
rel. On n'a pas de propagande, on ne dit pas, voilà ce qu'on
fait, voilà ce qu'on est. Qu'on essaye de rendre la musique
commerciale, ou qu'on essaye de la rendre bizarre,
l'essentiel, c'est
que ce soit ins-
tinctif, et dans
ce sens-là, je
crois qu'on
est primitif.
Je crois

15

designer
Robert Hunter

college
The Surrey Institute of
Art & Design, Farnham

country of origin
UK

work description
Spread from *Area 39*,
a magazine project
covering experimental
music, design, and
multimedia

dimensions
210 x 297 mm
8¼ x 11¾ in

AREA 39 LTD, 45-46 POLAND STREET, LONDON W1V 3DF TEL 071 439 6422 FAX: 071 287 4767

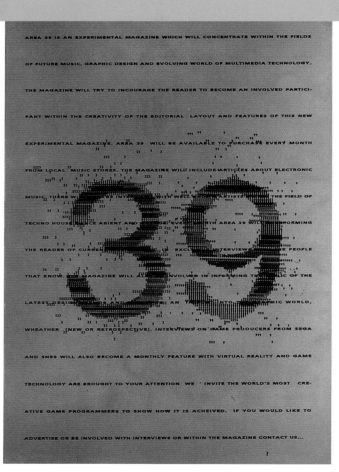

designer
Anthony Oram

college
The Surrey Institute of
Art & Design, Farnham

country of origin
UK

work description
Spread from *Area 39*,
a magazine project
covering experimental
music, design, and
multimedia

dimensions
297 x 420 mm
11¾ x 16½ in

usic Technology

CD-ROM

Where now for the intrepid explorer?

REAL WORLD MULTI-MEDIA PLANS TO INCREASE ITS OUTPUT
THE FIRST RELEASE ARRIVING IN THE SUMMER OF NEXT YEAR

Multi-Media is an excellent way to introduce CD-ROM

Where now for the intrepid explorer?

At the end of 1992, three records signalled a new
drift within and against the alternative rock/pop morass:
Earwig's Under My Skin I, Disco **intrepid explorer 1994**
Inferno's "Summer's Last Sound" EP, and, most fabulous of
all, Bark Psychosis's 20-minute single "Scum". Seen as an
alternative to the alternative, all three groups shared
Multi-Media is an exellant way to introduce CD-ROM
Real world Multi-Media plan to increase its output
in either East London or Brighton (where Earwig, now
Insides, and if Bark Psychosis's Graham Sutton resided).
More important was probably their varying use of sam-
plers, MIDI equipment and drum machines to distance them-
selves from both the conventional four-piece indie rock
band and the total-machine orientation of Ambient or
Techno. Along with Papa Sprain and Butterfly Child, who,
like Bark Psychosis, shar
and, like Insides, used drum machines creatively,
these groups signaled a refusal to conform to the domi-
neting models of indie and Techno. Acordingly, they
nearly disappeared down the separating chasm, into media
oblivion.

Both "Scum" and "Summer's Last
Sound" also shared either a heightened aware-
ness of or a fascination with the band's com-
mon working environment of the East End. The
minimal lyric on "Scum" – "It's all around
you... don't let us that we're all free" –
gestatedthe Stratford church where Bark Psychosis
rehearsed and, in a week of takes, record
the piece, was reflected by and suffused with the ambi-
ence the band deliberately allowed into the music. In
conversation, guitarist and singer Sutton recounts how
his dissatisfaction with the majority of Ambient music,
where effects and mixing desk wizardry take primacy over
the actual recording of sounds, led the band to mike up
the drumkit in particular ways, to avoid "over-clean"
lead rhythms, or record sequenced material off a PA set
up inside the church instead of directly off the desk.
Sutton readily admits the influence of jazz's tendency to
capture the dynamics of the recording environment as well
as the actual playing. On both "SCUM" and the group's
debut album Hex (released this month on Circa), Mark
Sinnett's drumming is pushed to the fore, with the rest
of the instrumentation (in the case of Hex, involving
over a dozen mus
boards, vibes and trumpet as well as bass and guitar)
lovingly draped around this central, gentle throb. It's
an approach which enables the album to be consumed as
undemanding ambience at low volumes, but at higher vol-
umes, the sense of hypnosis, atmosphere, of the music's
respiration prove to fascinating to be reduced to back-
ground noise. Just as Bark Psychosis's previous releases
distanced the band from the Big Black/Napa

designers
Andrew Hall
Stuart Brown

college
Falmouth College of Art

country of origin
UK

work description
Front cover and spread
from *Lizard*, the first
student magazine of
Falmouth College of Art

dimensions
210 x 210 mm
8¼ x 8¼ in

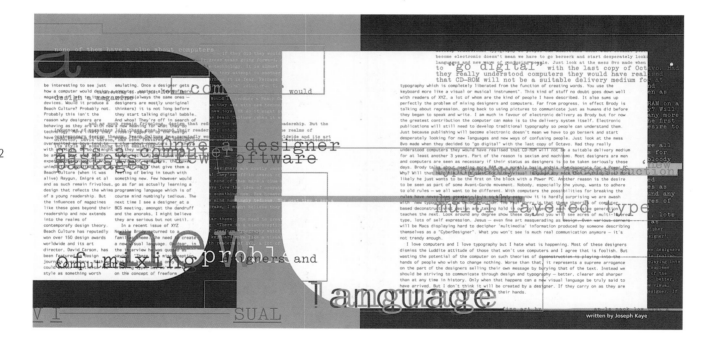

designer
Neil Fletcher

design company
Pd-p

country of origin
UK

work description
Front cover and spread
from the *Course
Representative Handbook*
for the Union of Students,
Sheffield Hallam
University

dimensions
210 x 297 mm
8¼ x 11¾ in

2

Sheffield Hallam University Union of **Students sees
the improving quality and relevancy
of your education as one of its major
priorities. >As a result the Education
Unit is in place** to co-ordinate all
of the Student Unions' educational
and representational work. **In providing s**upport for student
representa**tion at all
levels, raising** awareness
**of student rights and
developing a resource base to be used for
the benefit of all students at the University,
the Education Unit.→**

Education Unit
Course Rep Handbook: **Page two**

Education Unit Sheffield Hallam University Union of Students sees the improving quality and relevancy of your education as one of its major priorities. As a result the Education Unit is in place to co-ordinate all of the Student Unions' educational and representational work. In providing support for student representation at all levels, raising awareness of student rights and developing a resource base to be used for the benefit of all students at the University, the Education Unit has a strong commitment to achieving these objectives.
Who are we: VP Education: **Jane Whalen**, Education Research Officer: [hoping to appoint shortly], Student Services Administrator **Chris Smalley**, Education Officer: **Heather Ditch**.
Where are we: The Education Unit is based on the top floor of the Nelson Mandela Building, City Campus. You can contact us to make an appointment by: • calling in between 10 pm and 4 pm. • ringing up on 534125. • contact us through your Site Union Office. Advice Work Both the Education Research Officer and Jane can offer independent advice and information on a number of academic related problems. As a rep your role may be to speak to us on behalf of a student or to refer the student to see us themselves. For student reference we produce a number of booklets that you may find helpful:

Education Unit
Course Rep Handbook: Page three

1 Academic Appeals This covers the University regulations on what are considered grounds for appeal and how to go about it. The Education Research Officer or Jane will be happy to talk to you about an appeal.
2 Changing/Leaving Course You may decide you are on the wrong course or you may want to leave altogether.
This leaflet will give you some of the factual information you need to know such as any grant implications. Remember, it is always a good idea to talk to someone before you make your final decision. Again you may choose to talk on a student's behalf or refer them to the Education Unit or someone within the Department of Access & Guidance at the University.
3 Expulsions For Academic Reasons This leaflet explains what procedure the University must follow in the expulsion of students for academic reasons and the processes a student will be involved in if they're unfortunate enough to find themselves faced with expulsion. The leaflet lists the various grounds upon which an expulsion may be based.
These include an unsatisfactory standard of work and failure to meet specified levels of attendance. The leaflet explains the various routes which any expulsion case may follow, possible outcomes and what the student involved can do. 4 University Rules & Regulations On Cheating & Plagiarism This leaflet is our newest addition and has been produced to help the increasing numbers of students who are being accused of cheating. Since the old Polytechnics were granted University status, they now have the power to award their own degrees. However, a debate still continues as to whether their degrees are comparable to standard with those of any other University. Therefore, in an attempt to maintain the credibility and reputation of a Hallam degree, the University takes any form of cheating very seriously indeed. The leaflet aims to raise awareness on what is considered an **offense** by the University and what a student's rights are if they are accused and what they can expect to happen.
If you or any student you know is accused of cheating, make sure they come to talk to the Education Unit. Someone from the Unit will accompany that student to any hearing they may have to attend to ensure they are treated fairly. 5 The Placement Handbook This is available to all students due to go on work experience via your Placement Tutor. Whilst many University Schools also provide handbooks, the Union handbook is aimed to provide information of a more general nature and interest to students such as your money, other Unions, your health and safety and where to go if you're having problems.

3

type itself
type itself

designer
Edward Fella

country of origin
USA

typefaces
various

work description
A double-sided lecture
poster for Neville Brody,
using a visual vocabulary
designed to oppose that
of Brody's

dimensions
279 x 432 mm
11 x 17 in

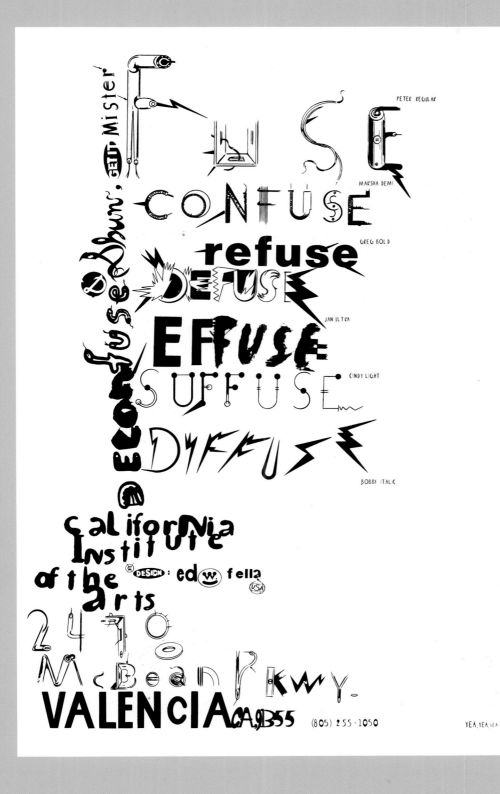

YEA, YEA, YEA

designer
David Bravenec

college
California Institute
of the Arts

country of origin
USA

typeface
Dactylo

work description
Typeface formed from
fingerprint fragments
melded with circuit bits,
shown on poster

dimensions
poster
457 x 610 mm
18 x 24 in

198

designer
Michael Ellot

college
The Surrey Institute of
Art & Design, Farnham

country of origin
UK

typeface
Phutik

work description
Typeface, shown in use on
magazine project

dimensions
page
210 x 297 mm
8¼ x 11¾ in

ABCDEFGHIJKLMNOPQRSTUVWXYZ

abcdefghijklmnopqrstuvwxyz

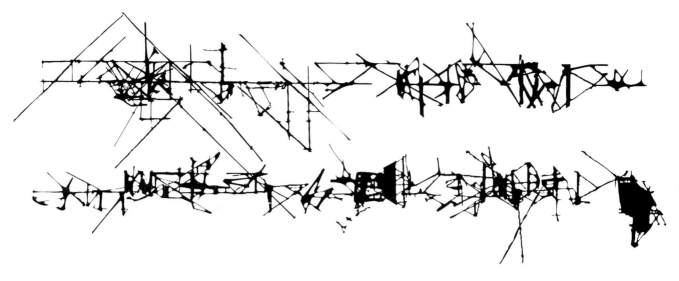

designer
Jason Bailey

college
Royal College of Art,
London

country of origin
UK

typeface
Network

work description
Typeface combining
digital networks with
organic growth

200

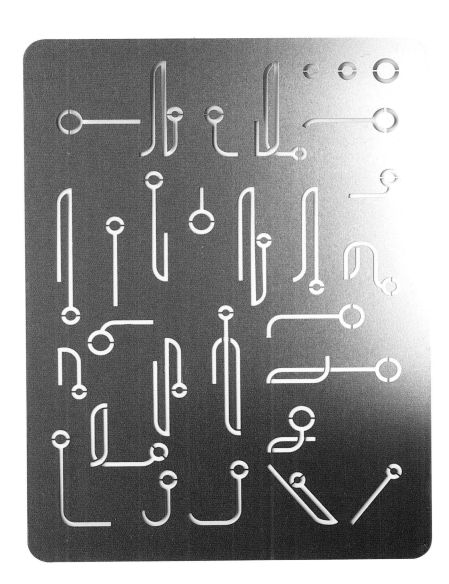

designer
Graham Evans

college
Royal College of Art,
London

country of origin
UK

typeface
Nails

work description
A typeface (shown left cut
out of metal) exploring
the oral/pictorial duality
of language as a written
form: verticals represent
explosive and implosive
sounds, horizontals
represent monothongs/
dipthongs, and the "nail
heads" vary in size
according to sound time

201

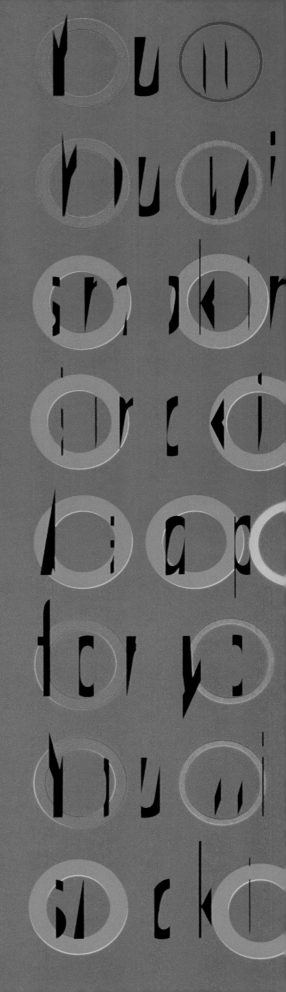

designer
Graham Evans

college
Royal College of Art,
London

country of origin
UK

typeface
Subliminal

work description
A typeface attempting to
visualize a message that
is subliminally received by
smokers who, under
general anesthetic for
surgery, are played a tape
telling them that they
want to give up smoking

202

dimensions
584 x 414 mm
23 x 16½ in

stops probably.

won to stop

will no longer

as readable activity

won to stop

as if now.

designer
Tom Hingston

country of origin
UK

typeface
Metro

work description
Typeface designed for
public information, shown
on advertising poster
(below, right) and on
experimental tickets for
the Metrolink tram
system in Manchester
(below, left)

dimensions
poster
594 x 420 mm
23⅜ x 16½ in

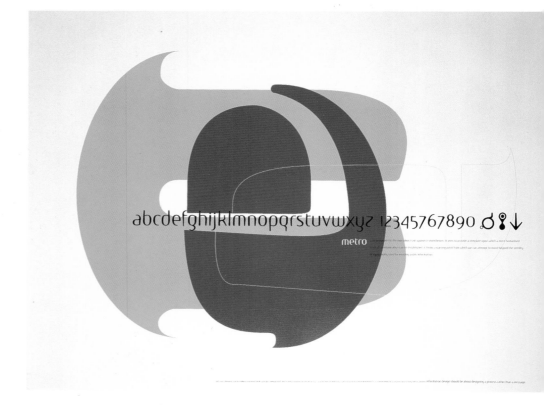

designers
Brigid McMullen
Nina Jenkins

art directors
Brigid McMullen
Martin Devlin

design company
The Workroom

country of origin
UK

typeface
Calculus

work description
Typeface designed for
the Chartered Institute
of Management
Accountants, shown on
front covers of brochures

dimensions
brochure, far left
220 x 310 mm
8⅝ x 12¼ in
others
210 x 297 mm
8¼ x 11¾ in

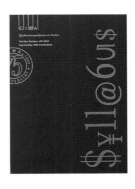

designer
Philippe Apeloig

design company
Philippe Apeloig Design

country of origin
France

typeface
Square

work description
New Year's Card

dimensions
card
180 x 180 mm
7 1/8 x 7 1/8 in

206

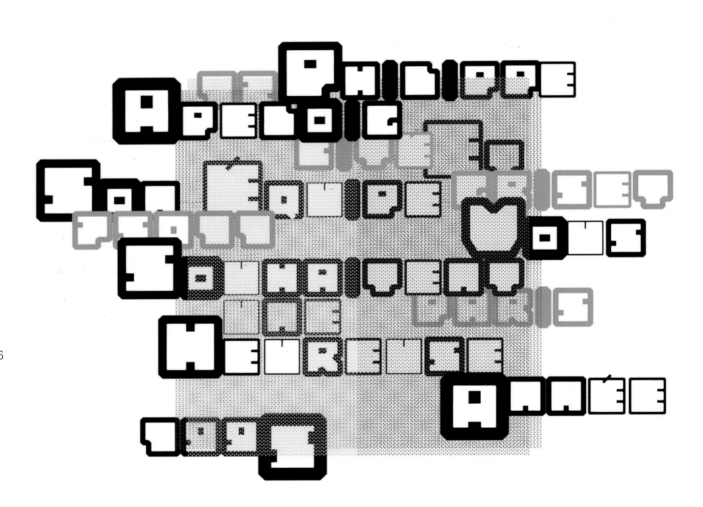

abcd ef g hi
A B C D E E G H
jklmn a p q
d K L M N O P Q
rst u xuu xyz
R S TUV WX YZ
123 45 678 9a

designer
Weston Bingham

college
California Institute of
the Arts

country of origin
USA

typeface
Baudrillard

work description
Typeface which
simulates features from
handwritten or hand-
lettered alphabets, but
disregards their original
contexts in favor of
computer generation

207

ABCDEF
GHIJKLM
NOPQRST
UVWXYZ

MR. KEEDY'S
"GRAPHIC DESIGN [IS] NOW"

THESE TWO POINTS
FOR WHEN CONTEXT
FOR UNIVERSALNESS:
ROOTED IN THE PAST.
IDEALS
X.
pre concieved idea of appropriateness

ARE INTER-RELATED
IS IGNORED NOTIONS
AND PRECONCEIVED
SURFACE THESE ARE
PARTICULARLY
MODERNIST AND
OF A CANNON OF
·THE PERSONAL CONTEXT

designer
Michael Worthington

college
California Institute of
the Arts

country of origin
USA

typefaces
Koo Koo Bloater (above)
Koo Koo Fatboy (center)
Koo Koo Bulemic (below)

work description
Typeface and spread from
Future Context magazine

dimensions
magazine spread
279 x 216 mm
11 x 8½ in

208

ABCDEFG
HIJKLMN
OPQRST
UVWXYZ

abcdef
ghijklm
nopqrst
uvwxyz

ABCDEFG abcdefg
HIJKLMN hijklmn
OPQRST opqrst
UVWXYZ uvwxyz

67890

abcdefg
hijklmn
opqrst
uvwxyz

designer
Richard Shanks

college
California Institute of
the Arts

country of origin
USA

typeface
Cardigan

work description
Typeface designed for
multimedia use, shown on
advertising poster

dimensions
508 x 610 mm
20 x 24 in

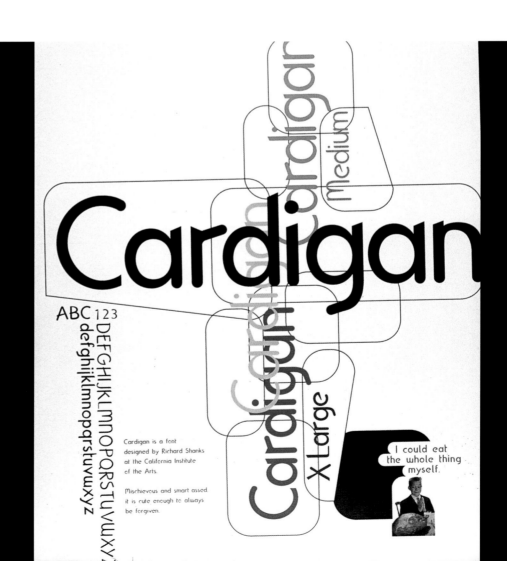

designer
Richard Shanks

college
California Institute of
the Arts

country of origin
USA

typeface
Taxi

work description
Retro-future typeface,
shown on advertising
poster

dimensions
508 x 610 mm
20 x 24 in

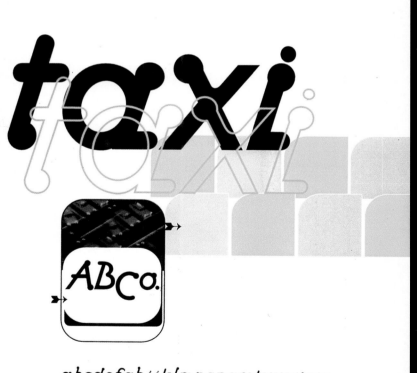

abcdefghijklmnopqrstuvwxyz
ABCDEFGHIJKLMNOPQRSTUVWXYZ

Taxi is a font designed by Richard Shanks

at the California Institute of the Arts.
It invokes an appreciation for the past
while signalling a direction for the future.

abcdefgh
stuvwxyz

designer
Vivienne Schott

college
The Surrey Institute of Art
& Design, Farnham

country of origin
UK

typeface
Blotter

a b c d e f g h i j k l m

n o p q r s t u v w x y z

A B C D E F G H I J K L

M N O P Q R S T U V W

X Y Z

C W P R

212

The history of art is simply a history of getting rid
of the ugly by entering into it, and using it.
After all, the notion of something outside of us
being ugly is not outside of us but inside of us.
And that's why I keep reiterating that we're
working with our minds. What we're trying to do
is to get them open so that we don't see things
as being ugly, or beautiful, but we see them just
as they are.

JOHN CAGE

The history of art is simply a history of getting rid
of the ugly by entering into it, and using it.
After all, the notion of something outside of us
being ugly is not outside of us but inside of us.
And that's why I keep reiterating that we're
working with our minds. What we're trying to do
is to get them open so that we don't see things
as being ugly, or beautiful, but we see them just
as they are.

JOHN CAGE

designer
Christian Küsters

college
Yale University School of
Art, Connecticut

country of origin
USA

typeface
Underwater

work description
Typeface shown in three
phases: the negative
underwater, the negative
drying, and the final print

dimensions
432 x 279mm
17 x 11 in

213

type designer
Edward Fella

designer
Rudy VanderLans

photographer
Rudy VanderLans

art director
Rudy VanderLans

design company
Emigre Graphics

country of origin
USA

typeface
Outwest

work description
Poster advertising
typeface

dimensions
570 x 830 mm
22½ x 32⅝ in

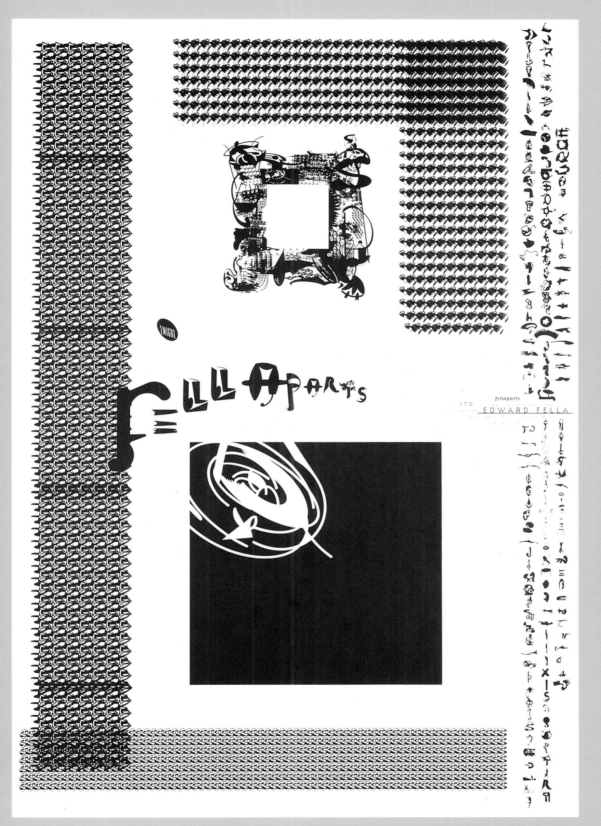

font illustrator
Edward Fella

designers
Gail Swanlund
Rudy VanderLans

art director
Rudy VanderLans

design company
Emigre Graphics

country of origin
USA

typeface
Fellaparts

work description
Poster advertising
typeface

dimensions
570 x 830 mm
22½ x 32⅝ in

designer
Conor Mangat

college
California Institute of
the Arts

country of origin
USA

typeface
Stereo Type

work description
Typeface exploring
stereotypical traits of
English and American
typography

dimensions
457 x 610 mm
18 x 24 in

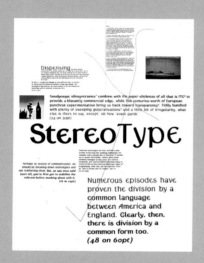

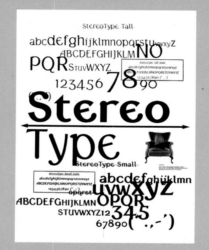

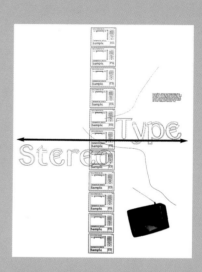

the bauhaus finally gets the cal-look! dining heartily on a slice of american car culture, platelet draws from the existing characters of californian license plates to create a whole host of new opportunities for the typographically-minded driver. AVAILABLE IN THREE COMPLEMENTARY FLAVOURS, PLATELET IS NOW AVAILABLE EXCLUSIVELY FROM EMIGRE FONTS. TO order, call 1-800-944-9021.

abcdefghijklmnopqrstuvwxyzABCDE
FGHIJKLMNOPQRSTUVWXYZ1234567890
#¶@£f$%*b™!&@?~§.

type and design: conor mangat, 1994 grateful thanks go to phil baines, rupert bassett, ravensbourne college, and the square red studio. mr reedy helped a bit too

Thin|Regular|Heavy

designer
Conor Mangat

college
California Institute of
the Arts

country of origin
USA

typeface
Platelet

work description
Typeface derived from the
characters of Californian
license plates, shown on
an advertisement for
Emigre fonts

dimensions
285 x 425 mm
11¼ x 16¾ in

designer
Michael Worthington

college
California Institute of
the Arts

country of origin
USA

typeface
Dominatrix

work description
Typeface, shown in use on
advertising poster

dimensions
poster
508 x 813 mm
20 x 32 in

ABCDEF abc
GHIJKL defghijkl
MNOP mnopqrs
QRSTU tuvwxyz
VWXYZ 1234

designer
Huw Morgan

country of origin
UK

work description
Ideas for a changeable
typeface, shown in a
sketch book

dimensions
292 x 406 mm
11½ x 16 in

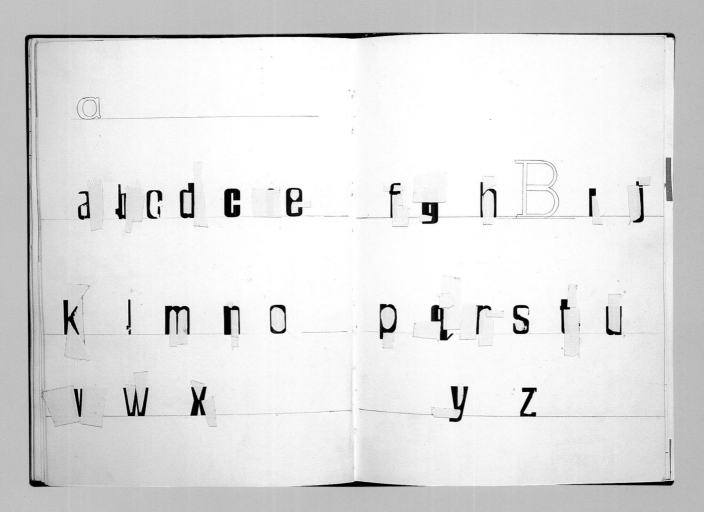

index

Index

223

List of Colleges

Atelier National de Création
Typographique
Imprimerie Nationale
12 bis rue du Capitaine Ménard
75732 Paris
France

Bath College of Higher Education
Sion Place
Lansdown
Bath BA1 5SF
UK

California Institute of the Arts
24700 McBean Parkway
Valencia
California 91355-2397
USA

Central Saint Martin's College of
Art and Design
Southhampton Row
London WC1B 4AP
UK

Cranbrook Academy of Arts
1221 N. Woodward Avenue
Bloomfield Hills
MI 48303
USA

Ecole Nationale Supérieure des Art
Décoratifs
31 rue d'Ulm
75005 Paris
France

Falmouth College of Art
Woodlane
Falmouth
Cornwall TR11 4RA
UK

London College of Printing and
Distributive Trades
Elephant and Castle
London SE1 6SB
UK

Ravensbourne College of Design
and Communication
Walden Road
Chislehurst
Kent BR7 5SN
UK

Royal College of Art
Kensington Gore
London SW7 2EU
UK

The Surrey Institute of Art
and Design
Falkner Road
Farnham
Surrey GU9 7DS
UK

Utrecht School of the Arts
Boueierbakker Laan 50
3582 VA
Utrecht
The Netherlands

Yale University School of Art
PO Box 2082412
New Haven
Connecticut
06520-8242
USA

Acknowledgments

The Publishers would like to thank
the following people for their help
in producing this book: Nick Bell,
Tony Cobb, Jennifer Harte,
Gabriella Le Grazie, Geoff White,
Karen Wilks for contacting
designers and educational
institutes; Peter Crowther
Associates for producing the
voiceprints reproduced on the
jacket and the chapter openers;
David Murray for photographing
some of the work.

Future Editions

If you would like to be included in
the call for entries for the next
edition of *Typographics* please
send your name and address to:
Typographics, Duncan Baird
Publishers, Castle House, Sixth
Floor, 75-76 Wells Street, London
W1P 3RE, UK. As a collection point
has not yet been finalized, samples
of work should not be forwarded
to this address.